about a
village

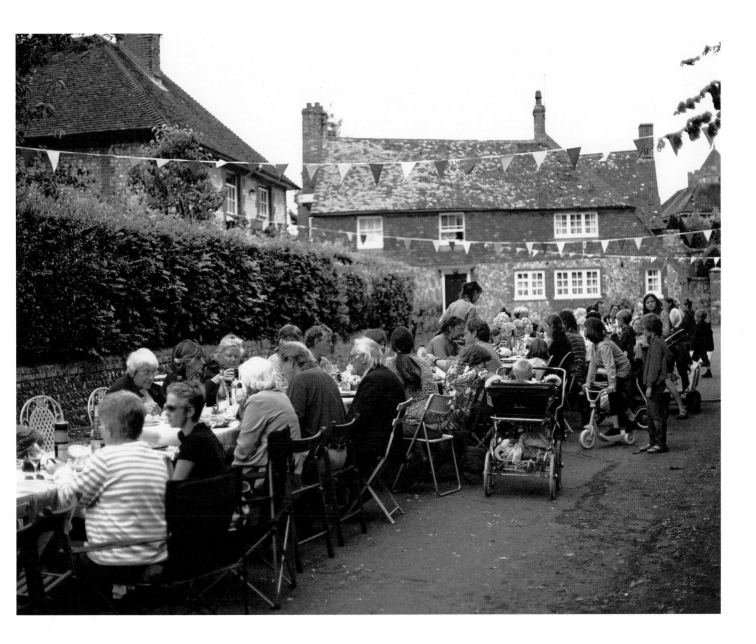

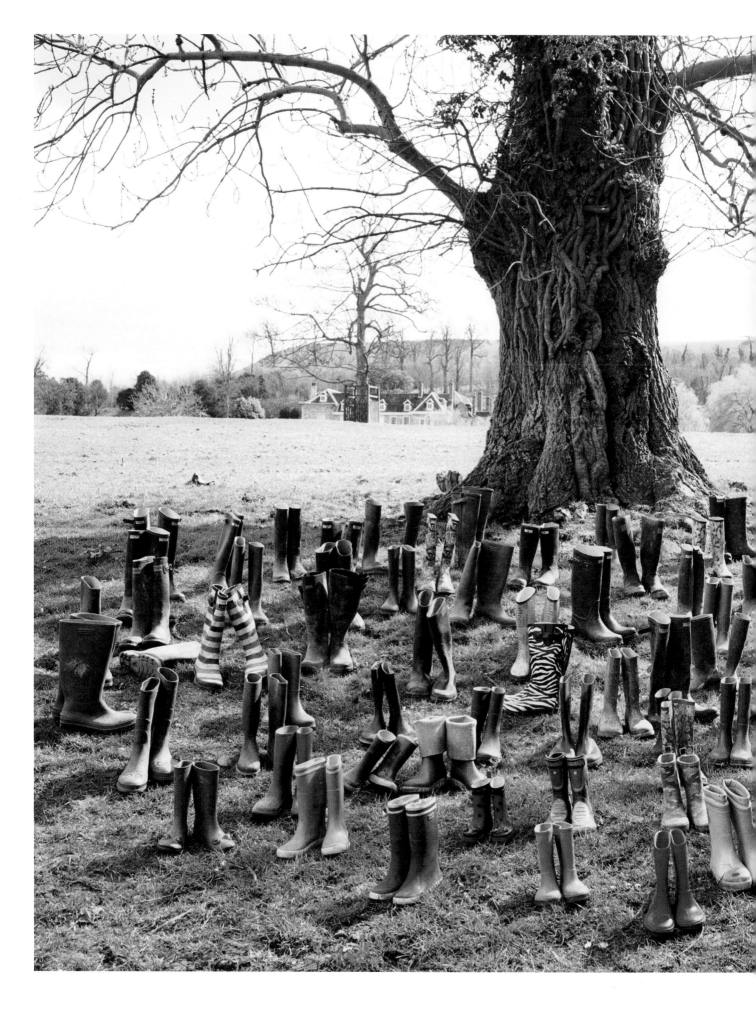

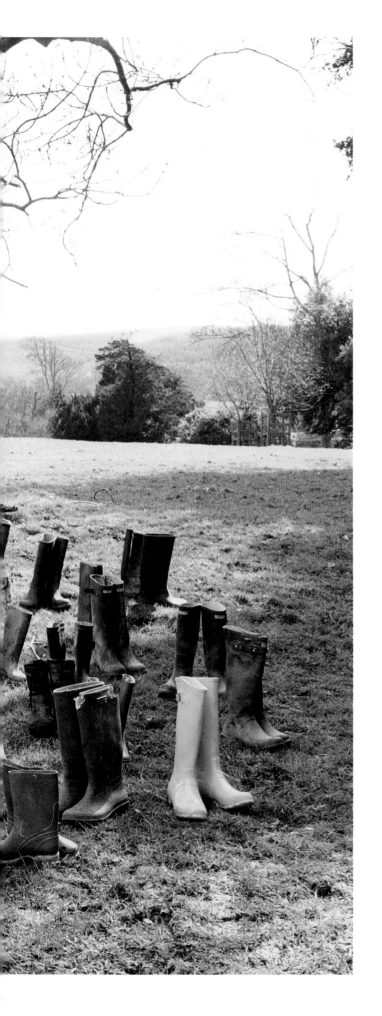

about a village

Photographs by
E. J. McCabe

Art Direction by
Karen Harrison

F

FRANCES LINCOLN LIMITED
PUBLISHERS

Frances Lincoln Ltd
4 Torriano Mews
Torriano Avenue
London NW5 2RZ
www.franceslincoln.com

About a Village
Copyright © Frances Lincoln Limited 2011
Text and photographs copyright © E. J. McCabe
First Frances Lincoln edition 2011

British Library Cataloguing-in-Publication data
A catalogue record for this book is available from the British Library.

ISBN: 978-0-7112-3258-7

Printed and bound in China

9 8 7 6 5 4 3 2 1

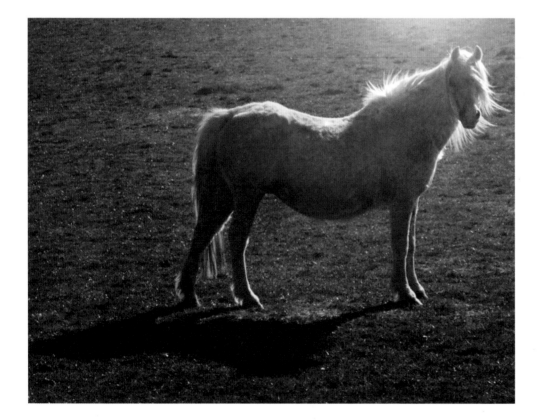

foreword

It is flattering to be asked to write a foreword for this ambitious photographic account of life in Firle village. These photographs portray a series of charming snatches of life and they are all of considerable quality. The impressionistic approach is enjoyable and unconventional and overcomes what some would say was a slightly dyed-in-the-wool view of Firle: it emphasizes that Firle is moving with the times! I hope that everyone will enjoy the book as much as I have.
Lord Gage, Firle Place

introduction

Firle sits literally at the end of the road. It is the last place you can reach by car before the road turns in the summer to a wandering line of chalk and in the winter something a little more muddy. Beyond the road are the Downs, sleeping and keeping the bones of those who were the first to arrive at the end of the last ice age. Wild land is a rare thing in Southern England; space for marbled white butterflies, glow worms and stands of trees and gorse that feel as if they are rarely entered, only ever half known. What I have only recently come to appreciate is that the village rests beneath trees, so there is this wonderful gradation which reads; the hills, the trees, the houses, and finally us. Those of us who live here are so wonderfully small in comparison to what surrounds us, and somehow that produces a great sense of vitality; the reassuring truth that the world is always bigger than we are.

Perhaps there is a perfect size for a village to be and maybe that size is not so big that it can be dominated by one particular interest group and not so small that it struggles to belong to itself. The unifying factor in Firle is that the vast majority of us are tenants – we live in what is known as 'an estate village'. Most of the village is owned by one extraordinary family. I have heard it said that coming to this village is 'like going back in time'. I don't see it that way at all. First of all, every village is unique; some are cussed, some, even on a blue summer's day, have an air of sadness about them. Some are gracious and some aren't. But most villages are made by hands that have long since gone, leaving reminders of an intimacy that mattered to them; the paths trod by the shepherds, each flint laid by hand.

There is no such thing as a rural idyll; lives begin and at times break, but here perhaps we are closer to the land and therefore closer to those who shaped it. It is a mistake to see villages as unchanging, to need them to be that thing beyond your life which is something good, something wholesome. The one unique thing about Firle is that everybody who lives here loves living here. That is something that is felt by those who come here, it's in the air. Far from 'going back in time', just imagine if this could be our future. That we could build and create communities that human beings really enjoyed living in. This book is an expression of the reality of that hope.
Reverend Peter Owen Jones

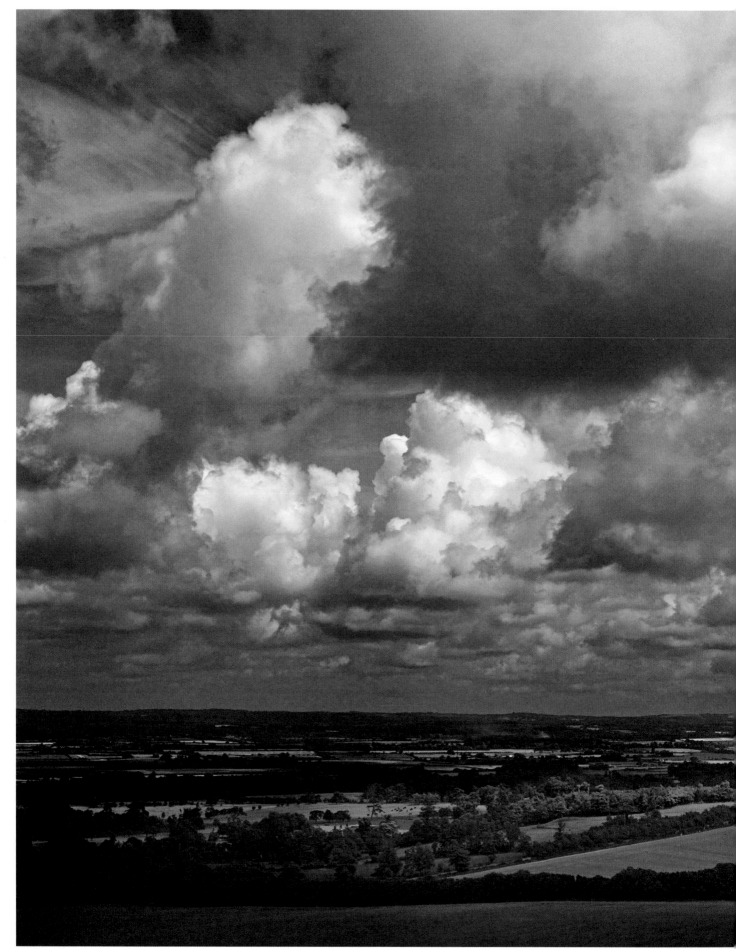

'So wonderfully small in our surroundings'.

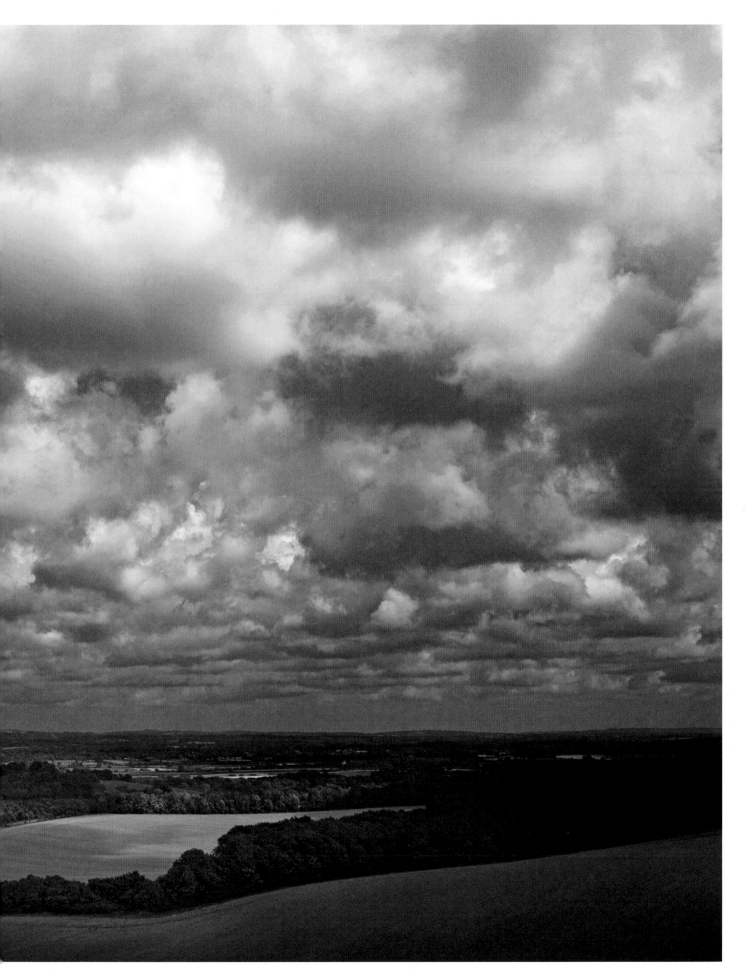

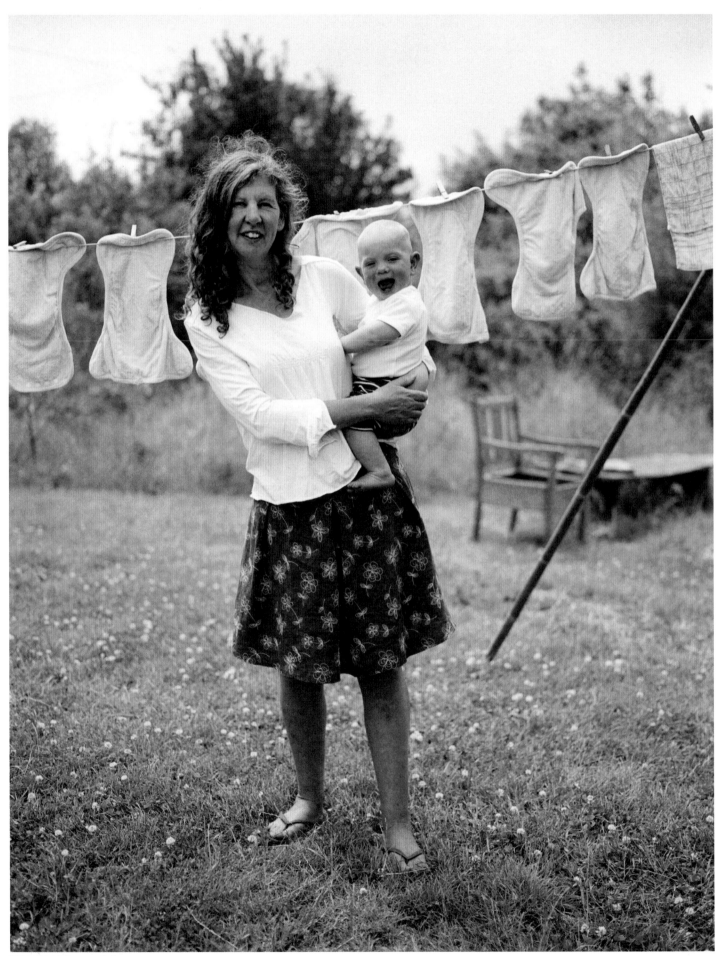

Helen and Eden, wash day.

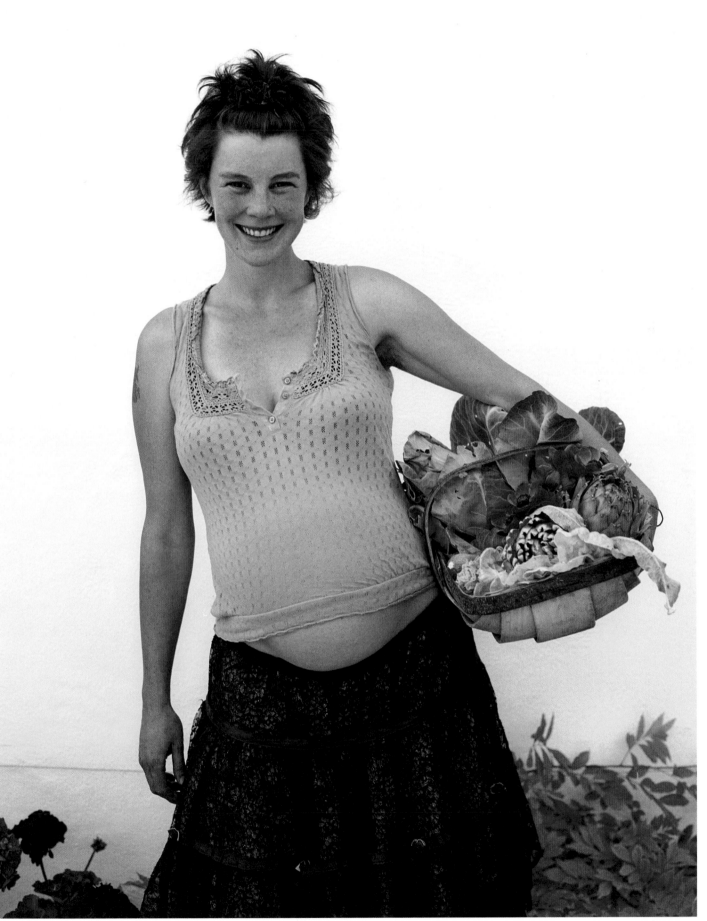

Ellen – all home grown! And growing.

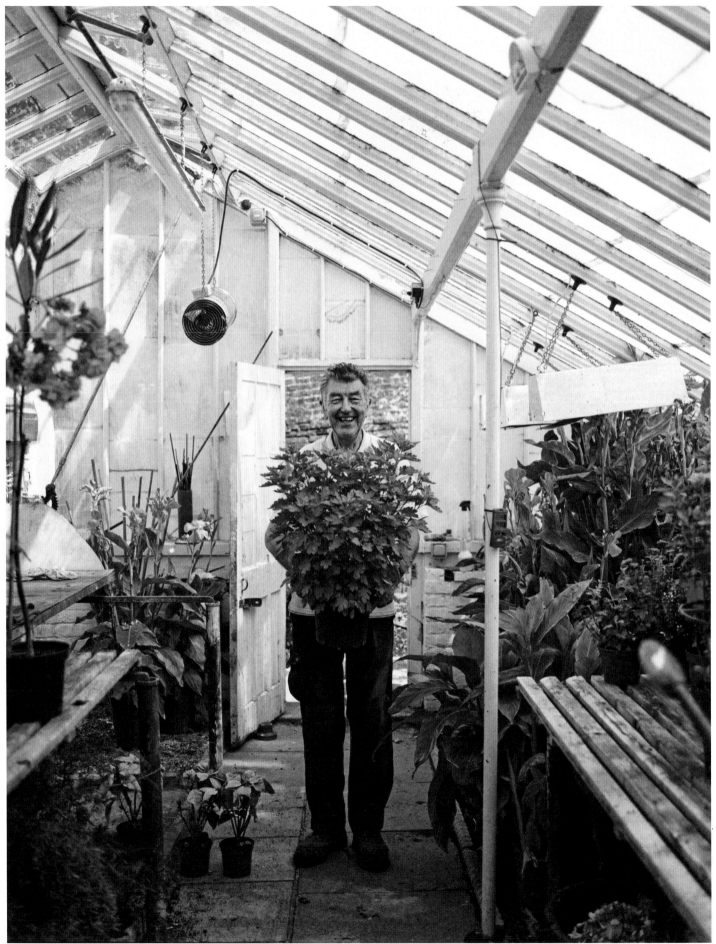

John has worked for years as one of four gardeners at Firle Place, home of the Gage family. The Gages have lived in Firle for over five hundred years, since 1476.

The yearly summer fête, sheep racing and all!

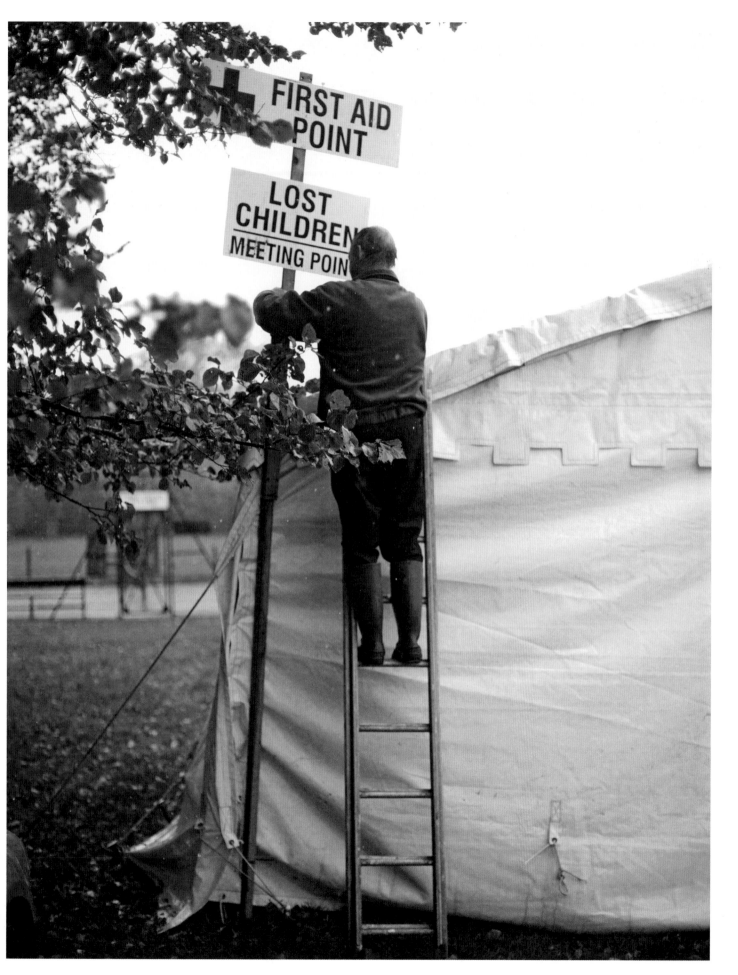

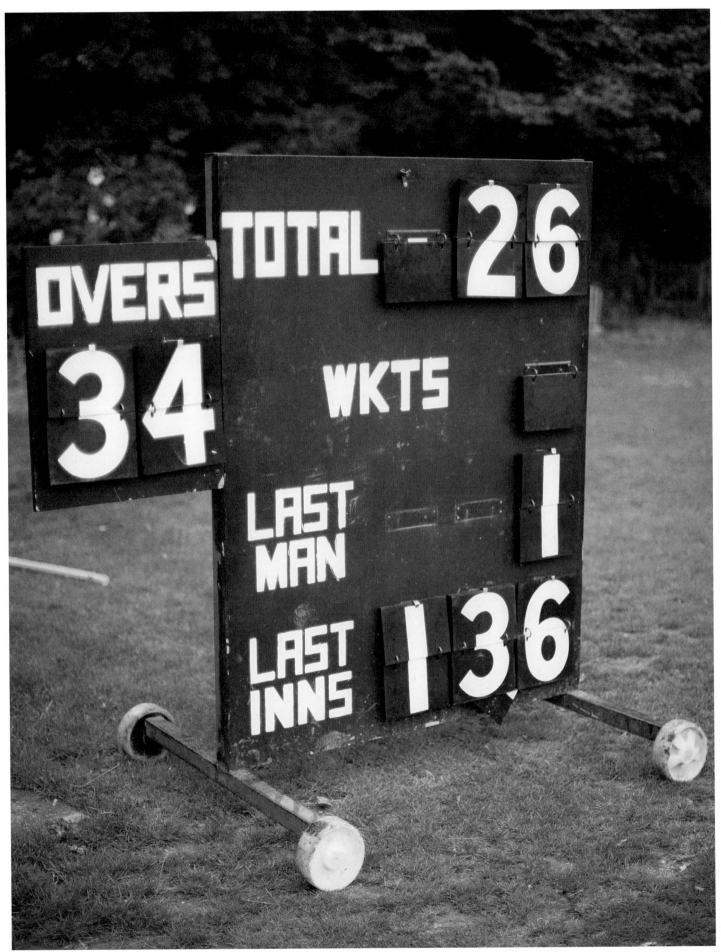

Every English village worth its salt has a cricket club. Firle's is one of the oldest in the country, founded in 1758.

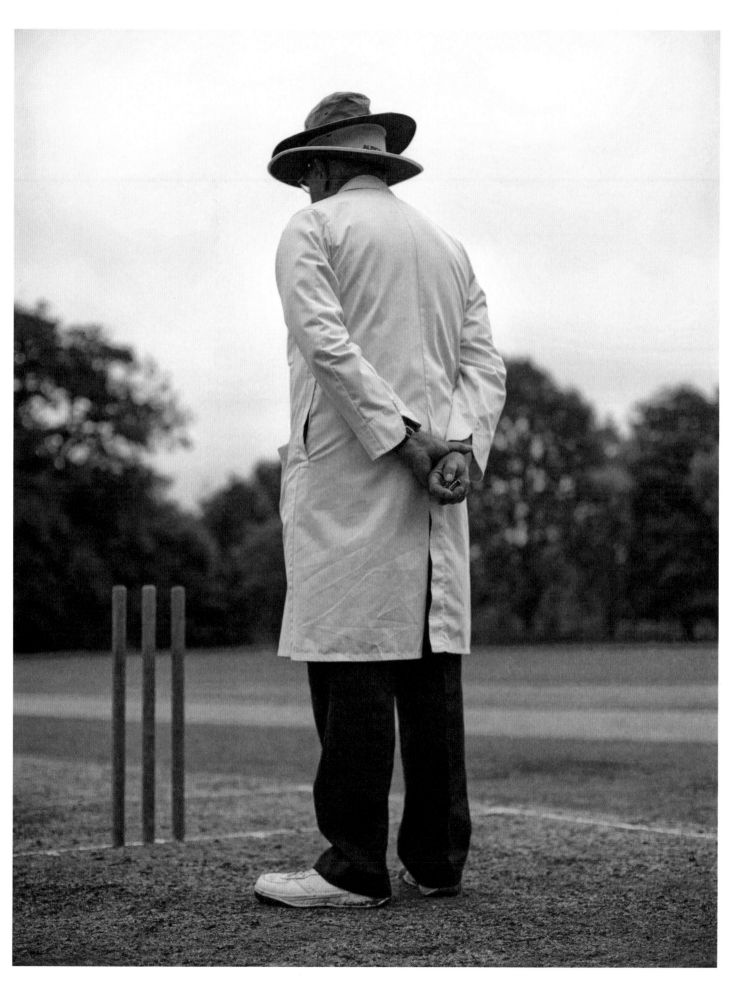

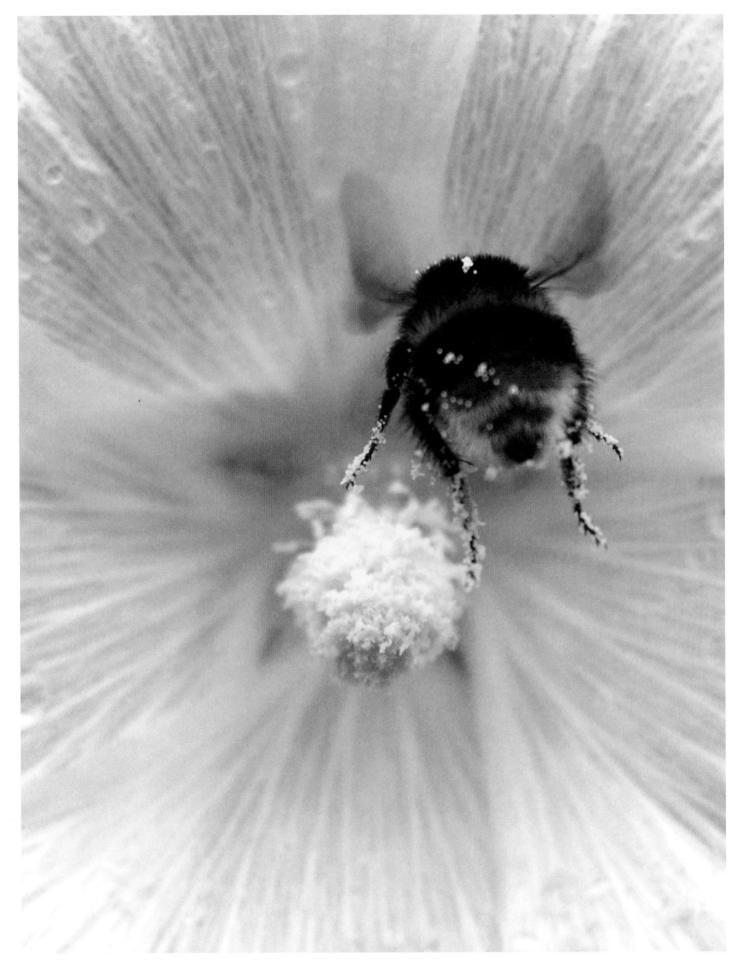

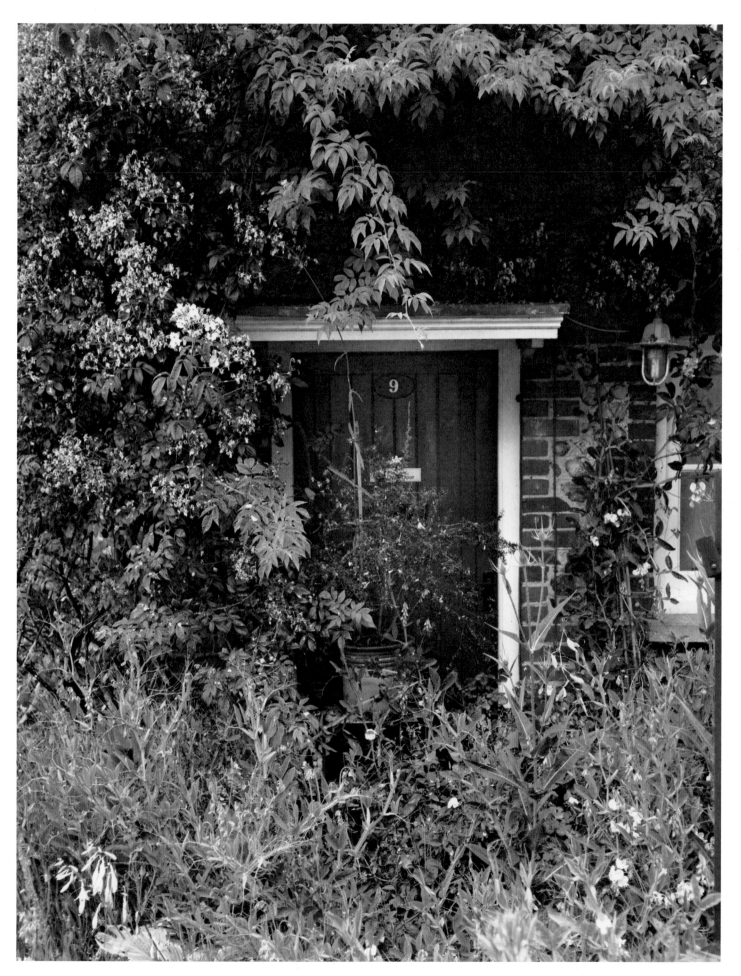

CHERRY PLUM JAM WITH LEMON
ZEST. GOOSEBERRY COOKED
WITH ELDERFLOWER NOW SOON

ALL POTS & LIDS ARE NEW.
APRICOT £2.50 POT
LOGANBERRY
APRICOT NOW SOLD
MORE NEXT WEEK

SOON GREEN TOMATO
CHUTNEY!

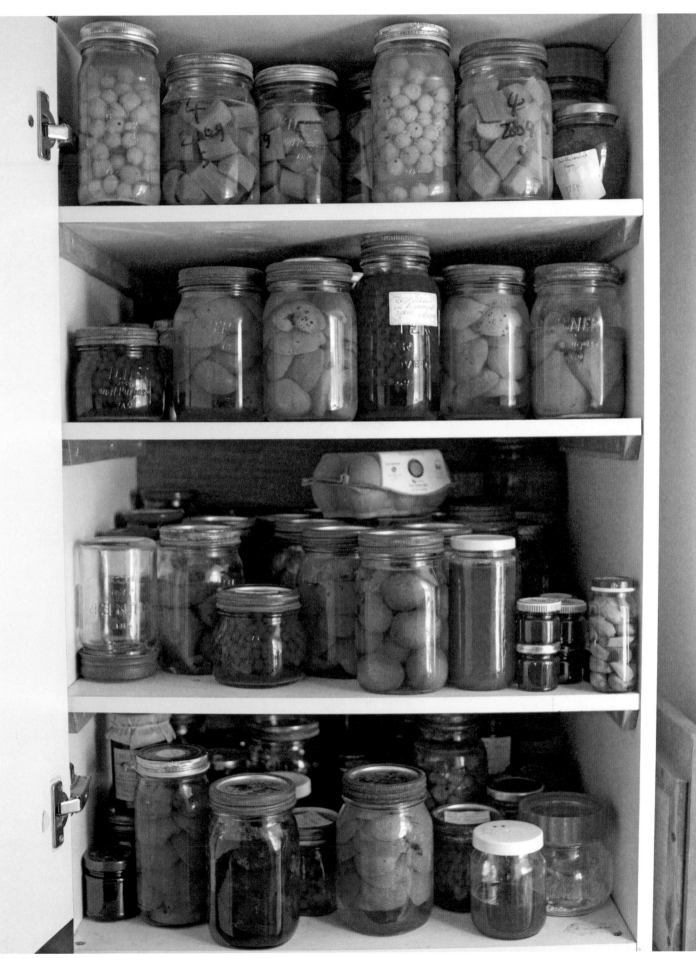

Ken's homemade preserves.

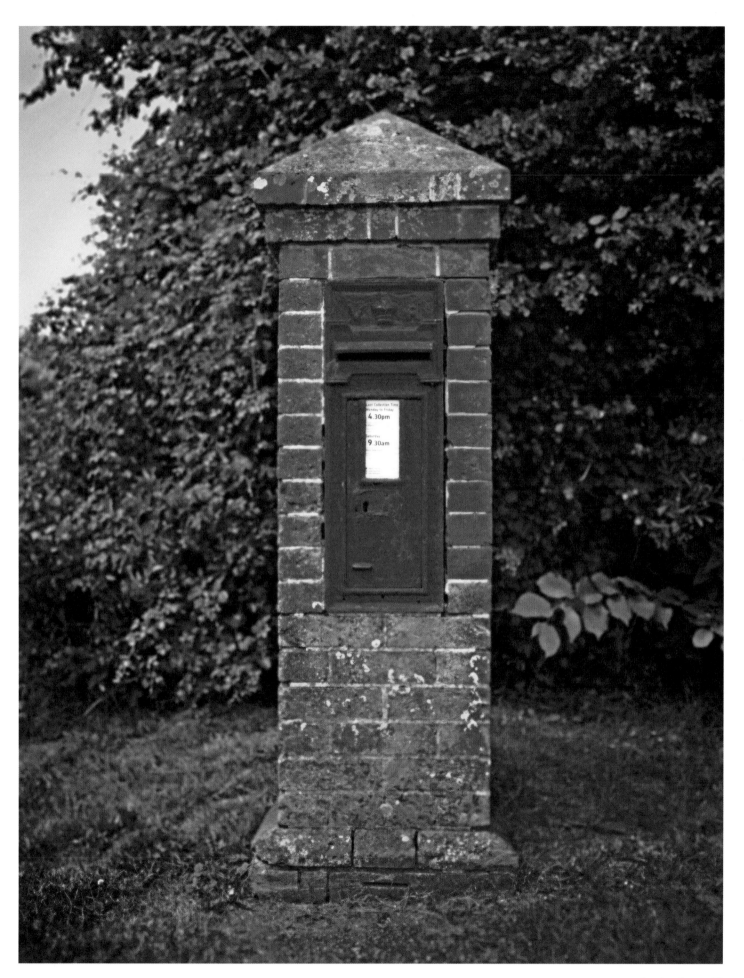

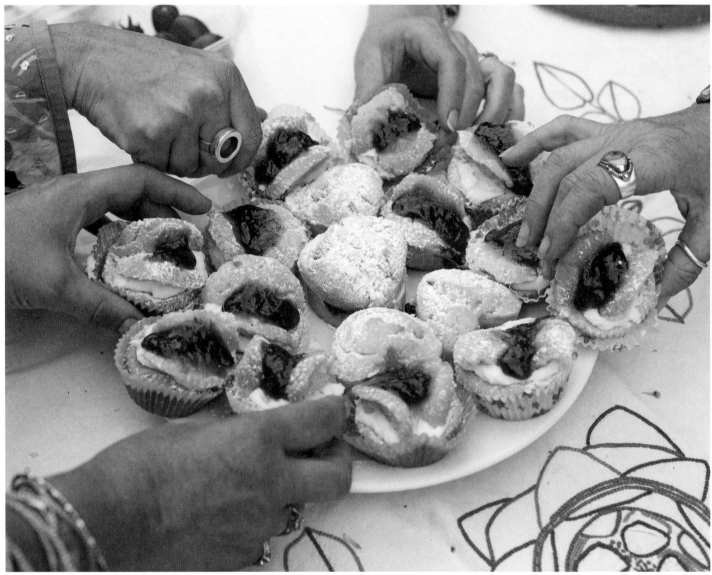

A street party fund raiser for the Village Hall.

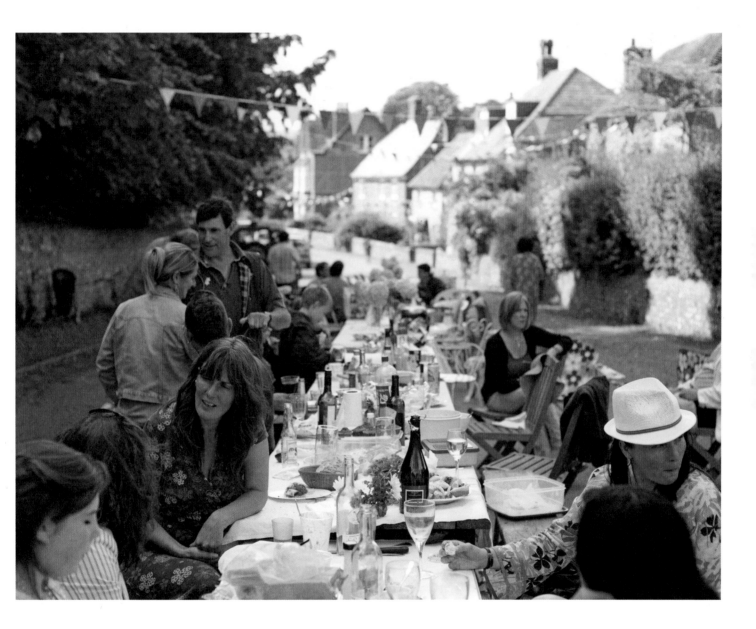

25 House Points

Presented to

Harvey Harrison-Doyle

Well Done!

Signed: MISS P

FIRLE SCHOOL

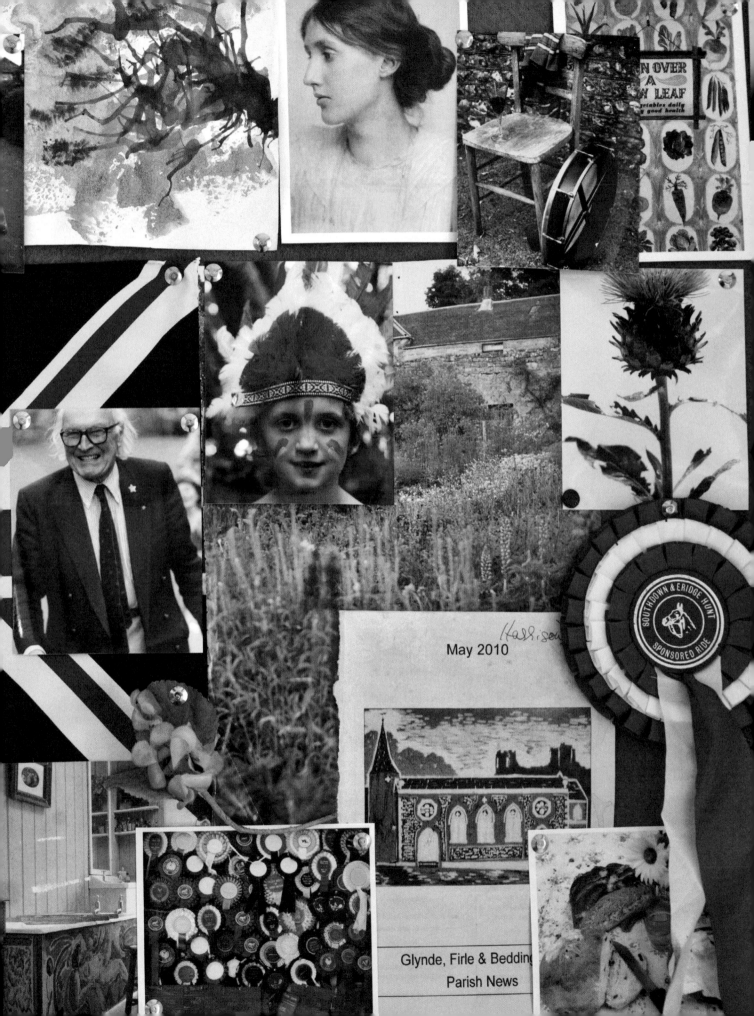

OVER
A
LEAF

May 2010

SOUTHDOWN & ERIDGE HUNT
SPONSORED RIDE

Glynde, Firle & Beddin
Parish News

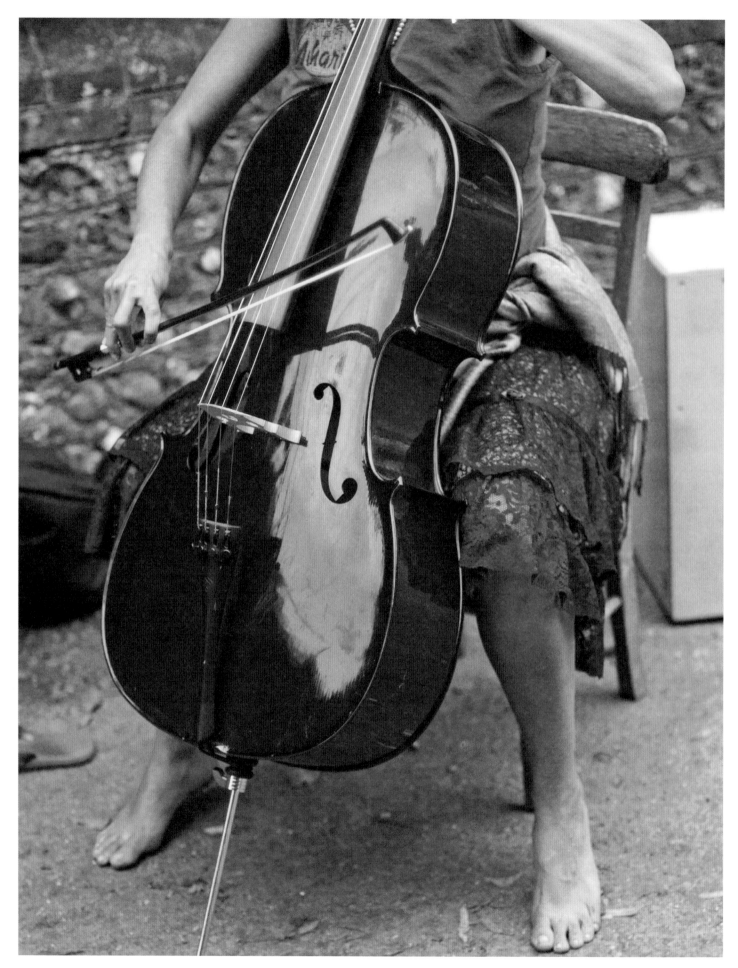

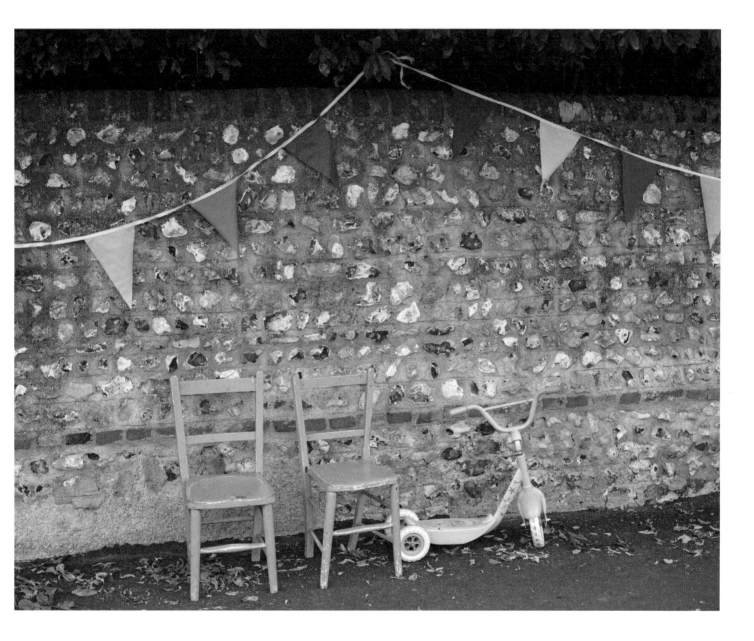

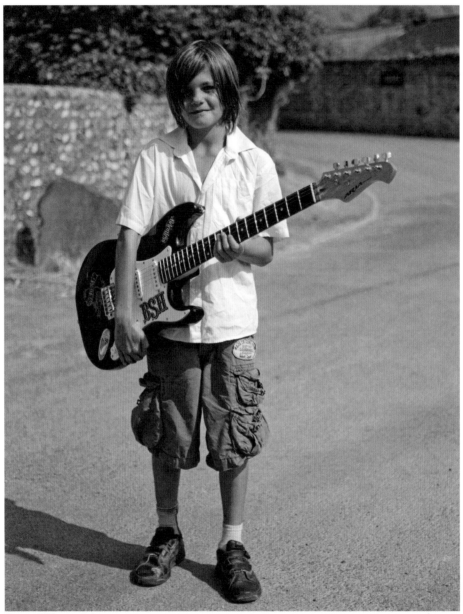

Above: Off to music lessons
Right: Everything that happens in the village happens here in the Village Hall; serious committee meetings, the over-fifties club, pilates, parties and the yearly panto. Once a week it becomes the Friday cafe where villagers can meet up for tea, homemade cakes and a gossip.

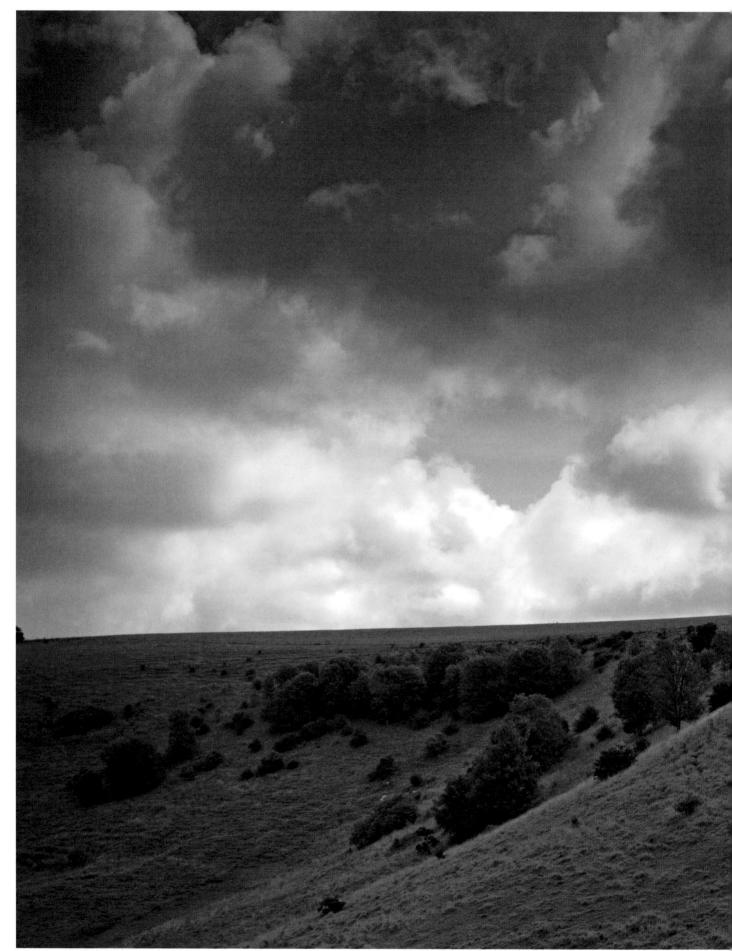

Firle Beacon is one of the South Downs beacons where fires were lit to warn of enemies approaching. Nowadays people go there for the magnificent views.

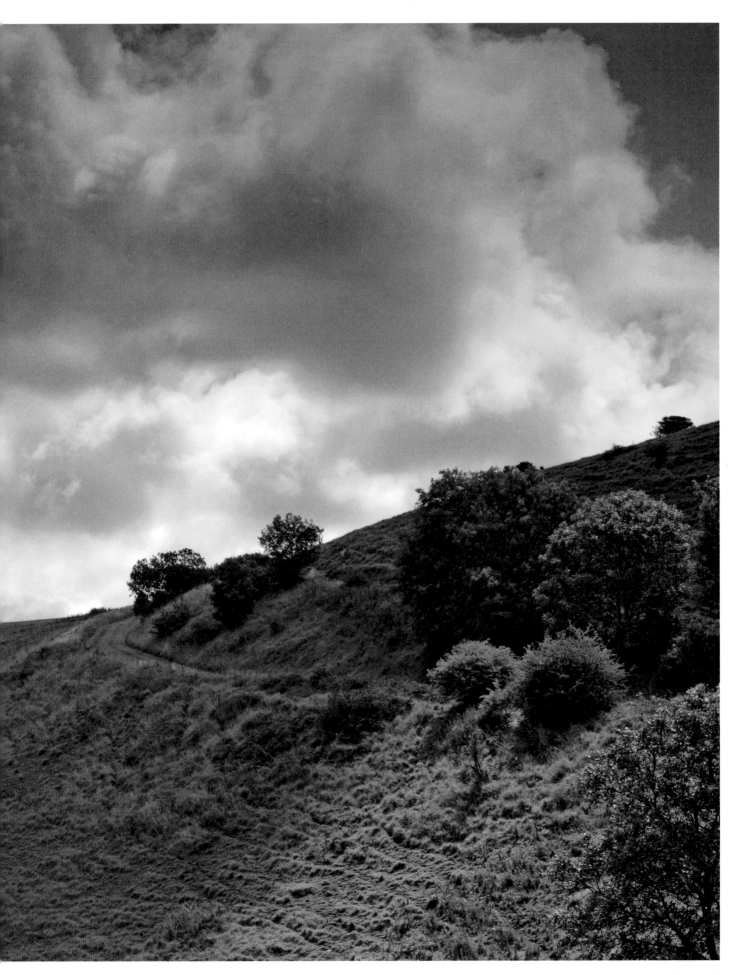

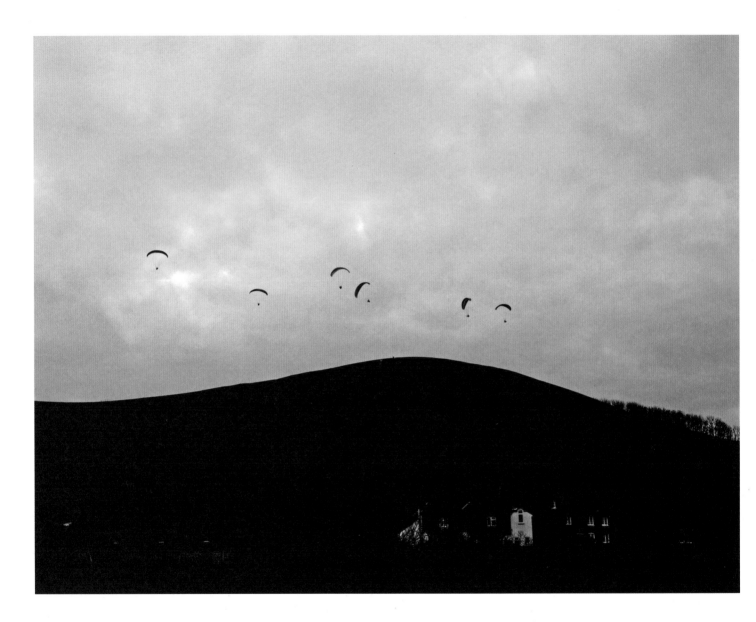

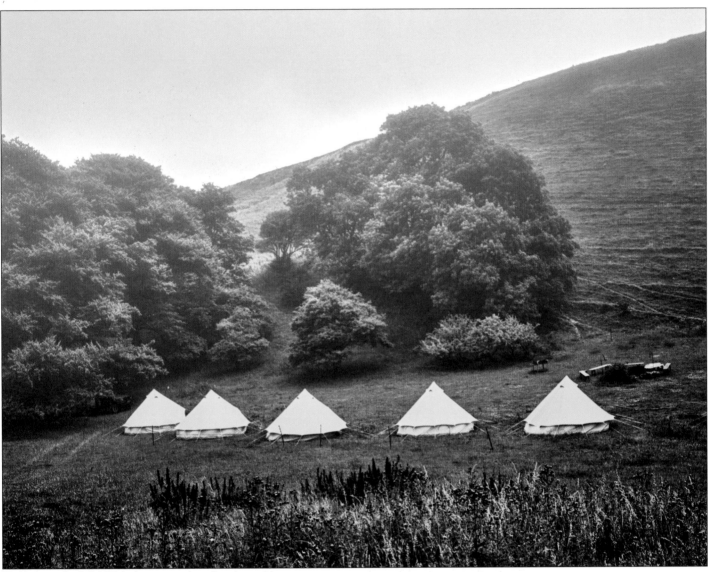

Pitching tents for Safari Britain, luxury camping with nature guides.

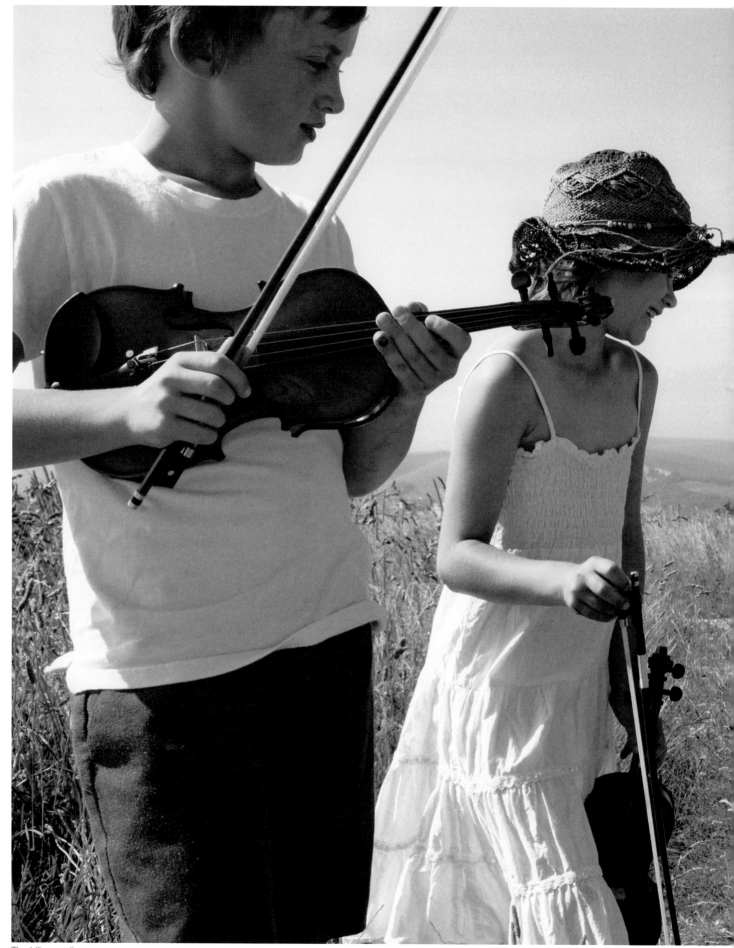

The hills are alive . . .

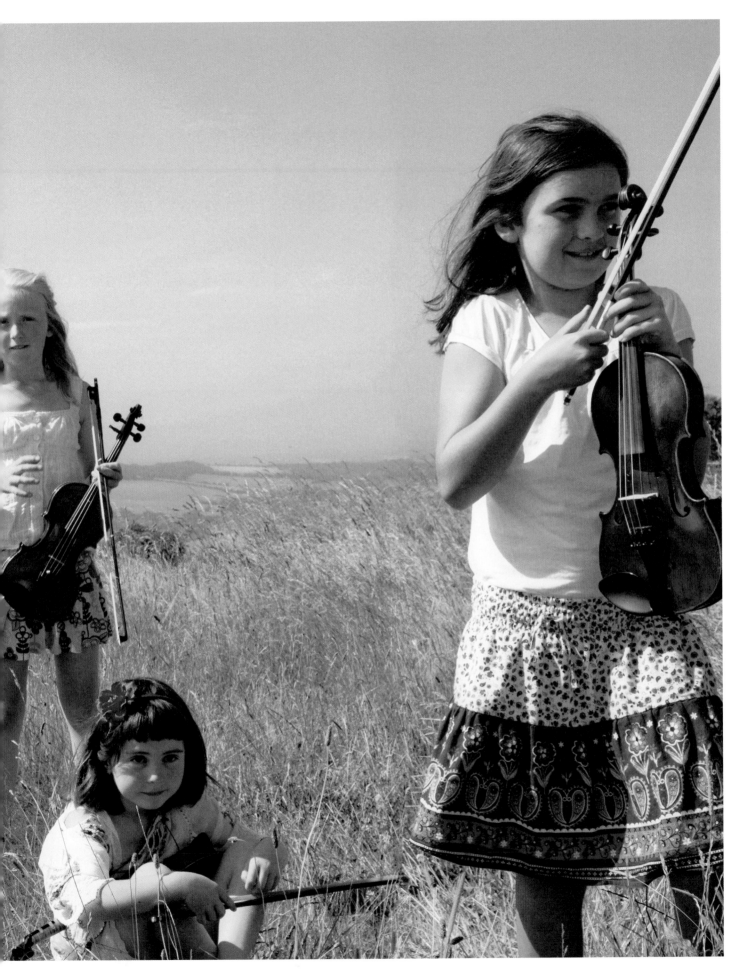

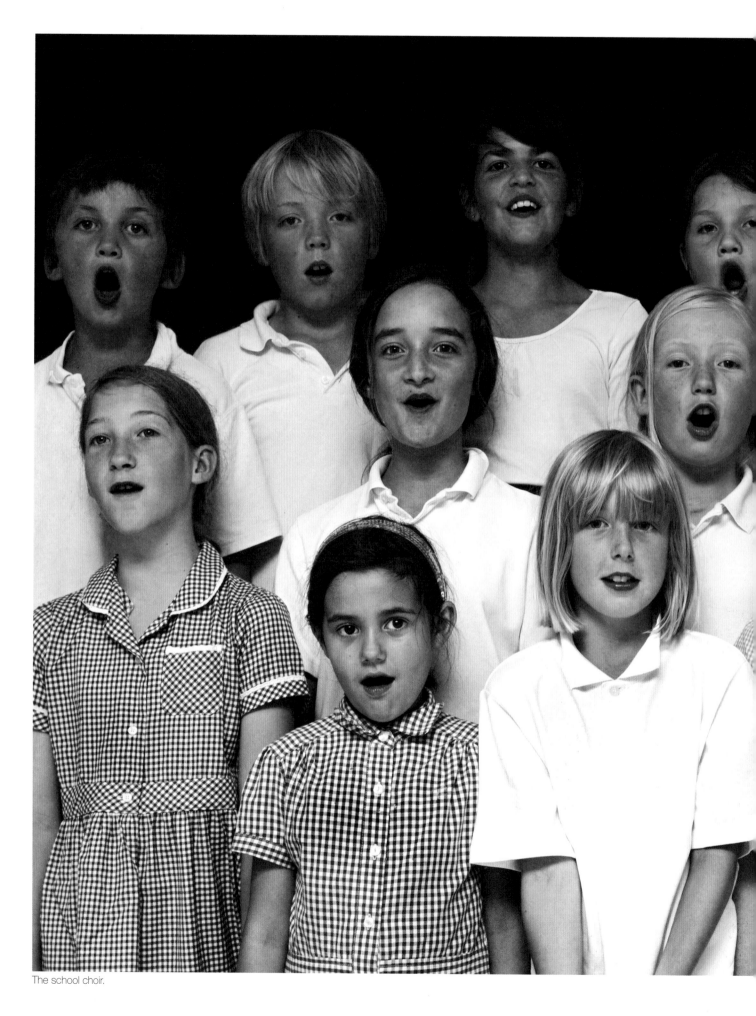

The school choir.

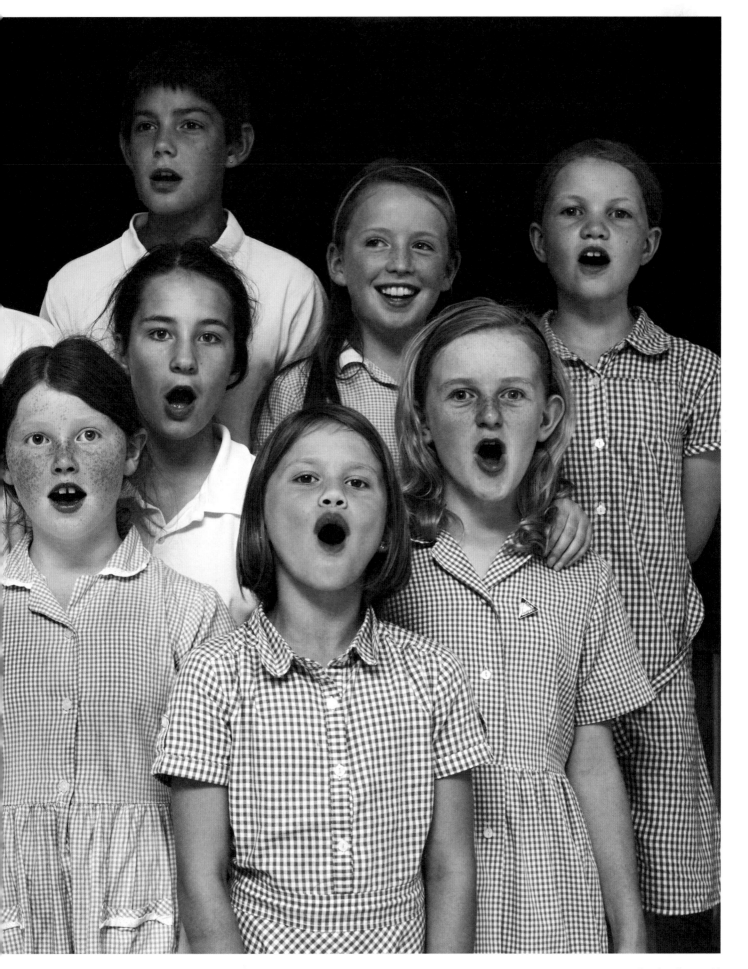

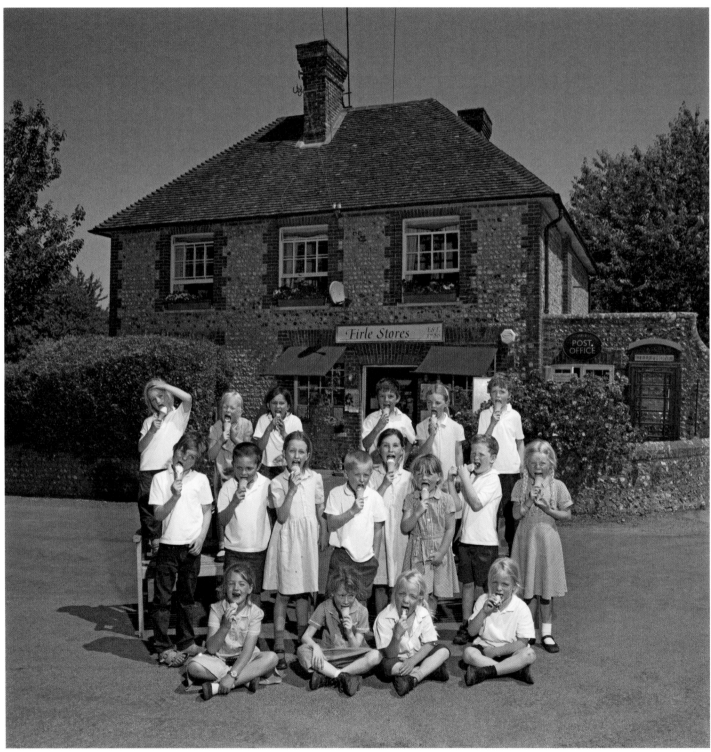

After school treats!

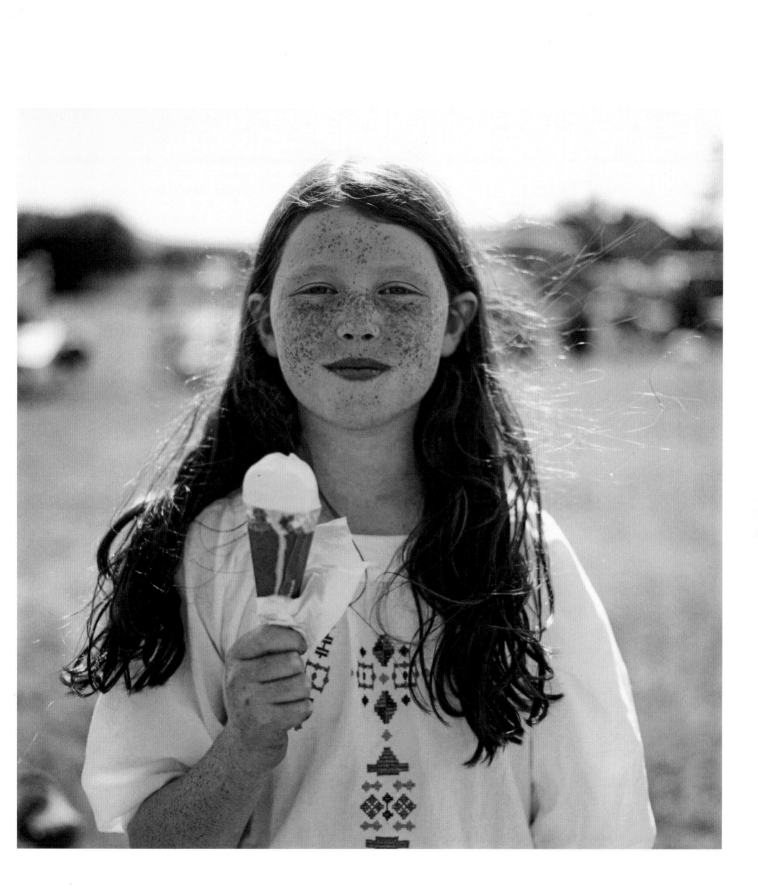

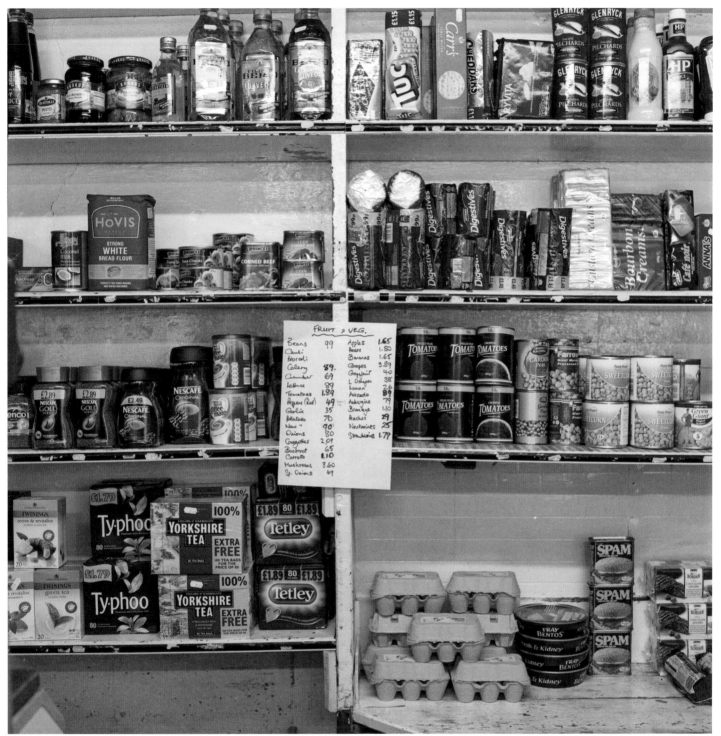

The hub of the village, the shop and post-office is a blessing in this modern day. A place to meet and have a chat as well as providing the essentials, all without having to get in the car.

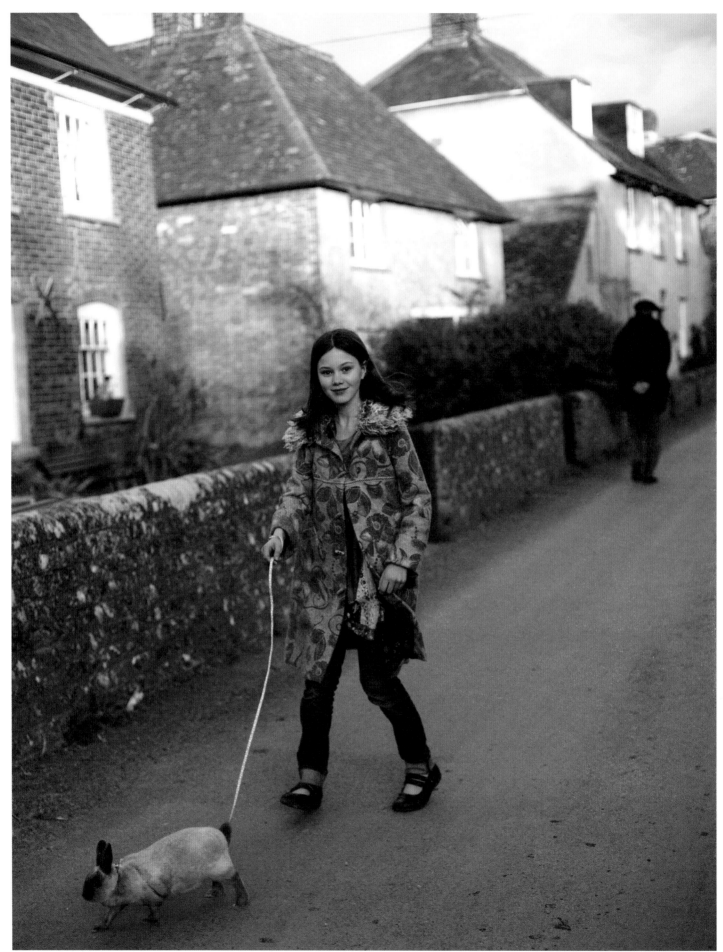

Taking Heidi for a walk.

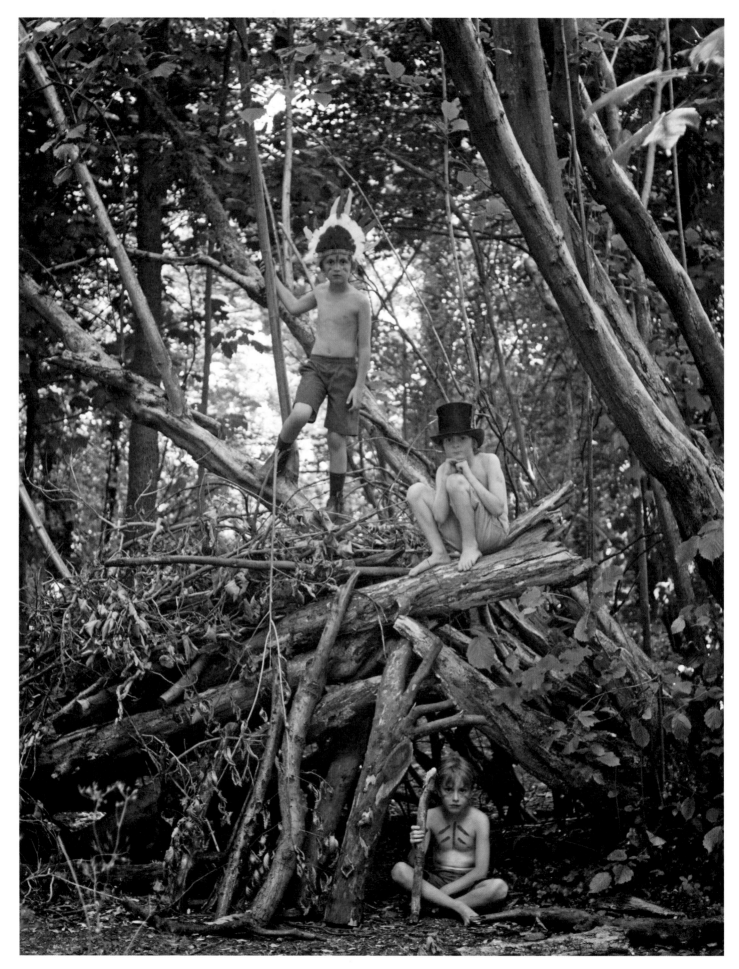

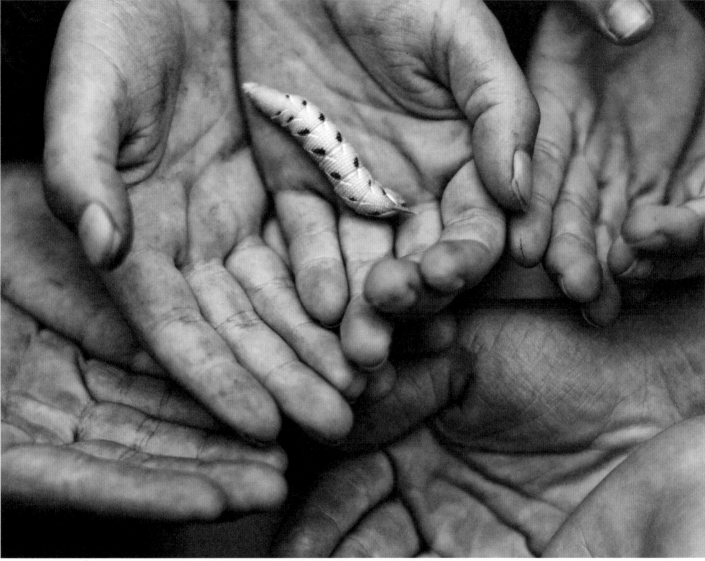

Boys at play.

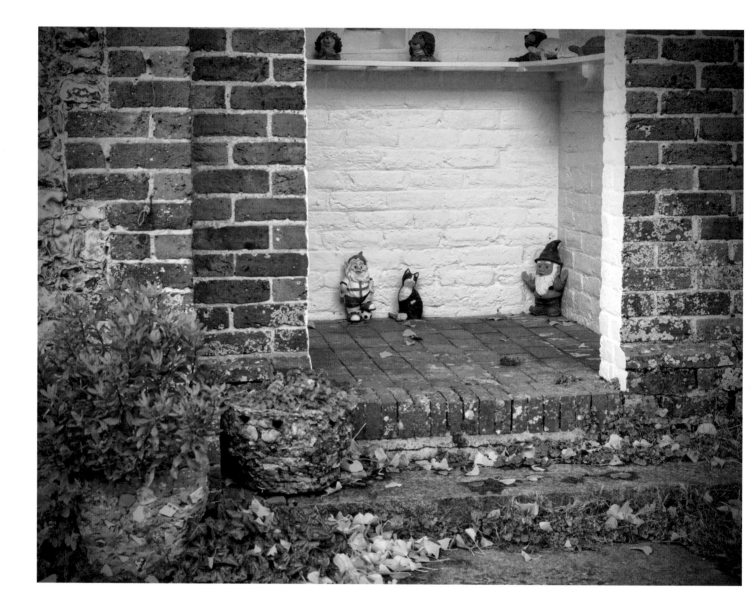

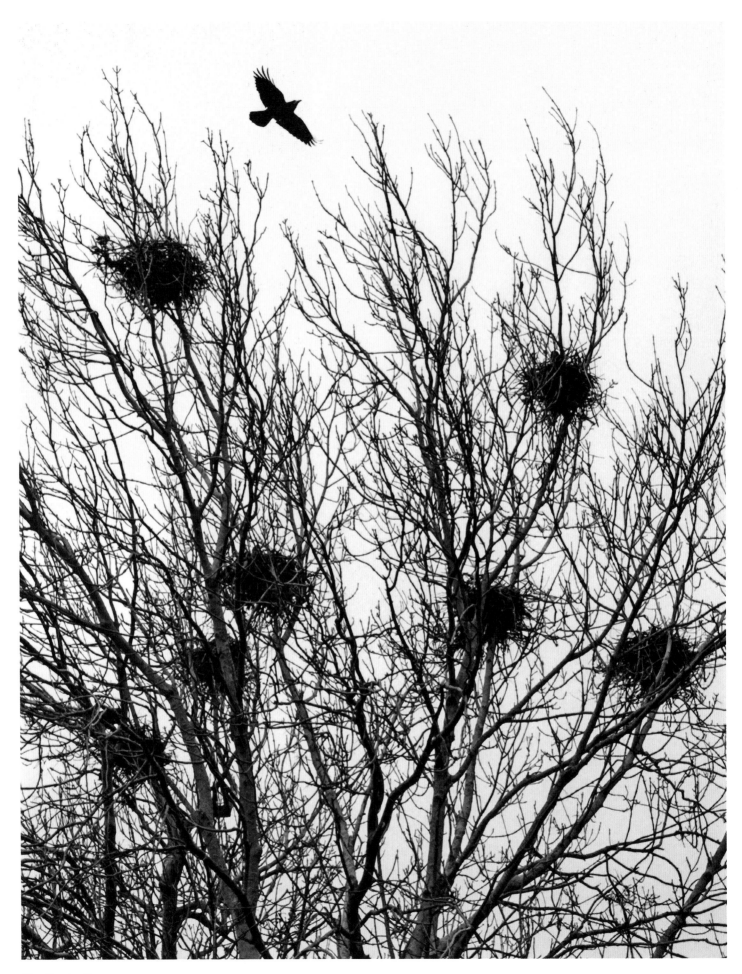

The allotment.

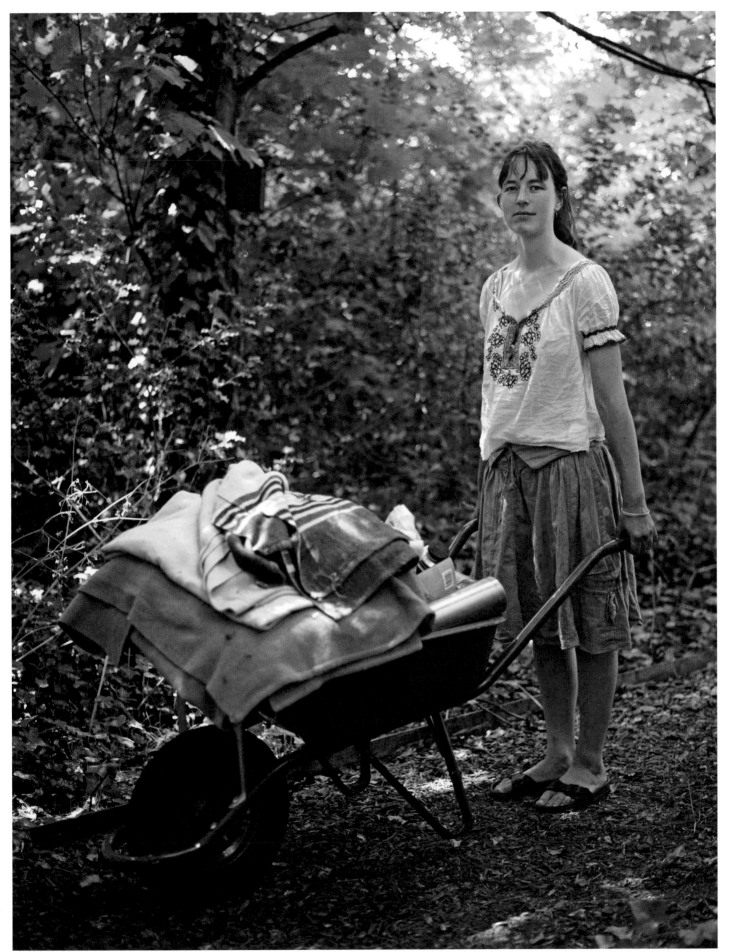

Anna runs foraging courses in the village.

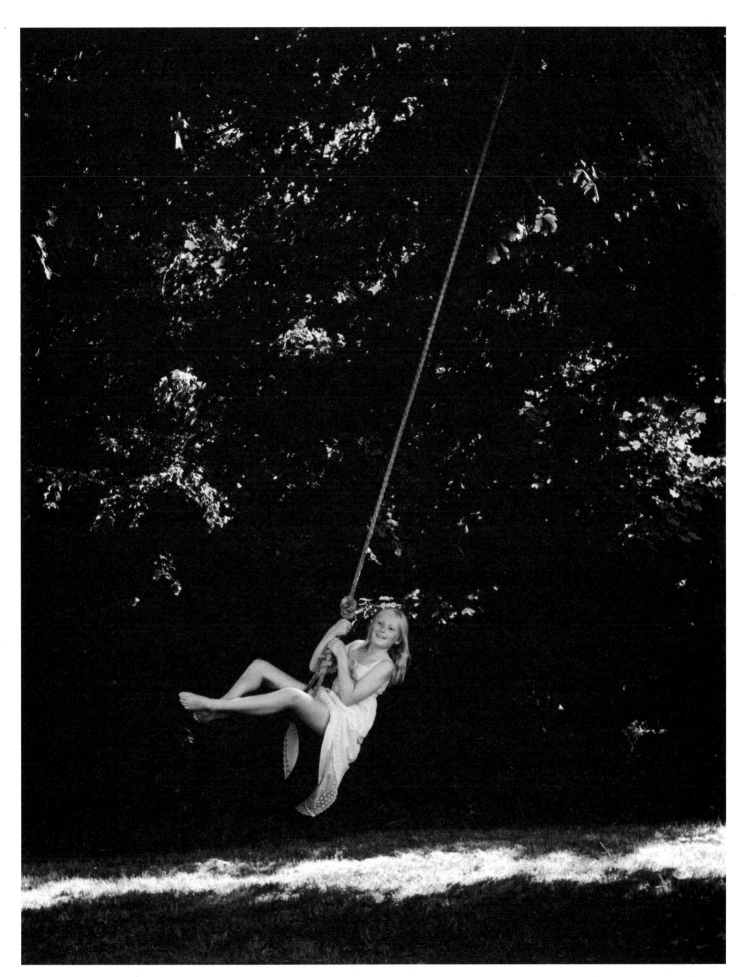

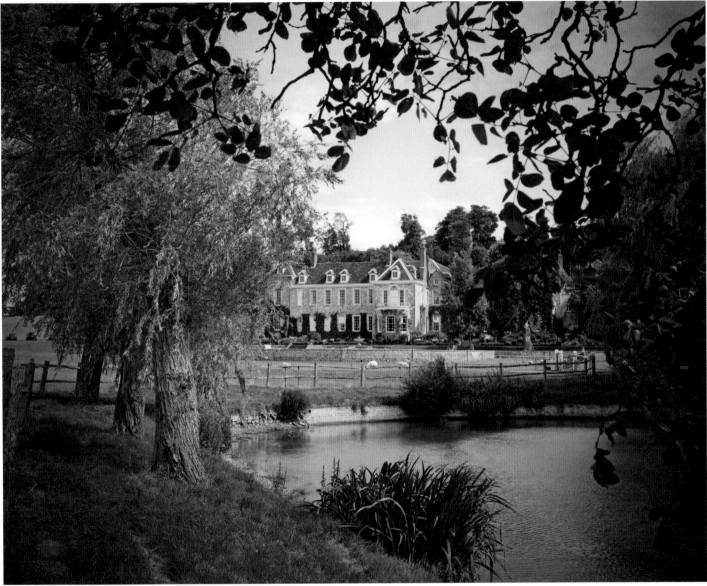

Firle Place.

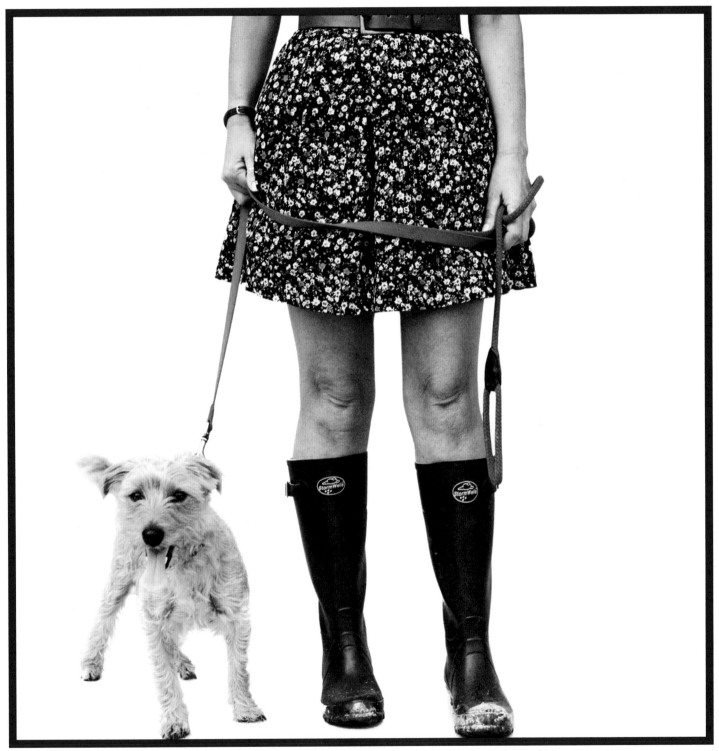

Terrie and Eddie.

Canine members of the village. From left to right: Alfie and Chan, Johnny 5, Flloyd, Max and Ziggy, Star, Ziggy, Ruby and Milly, Poppy

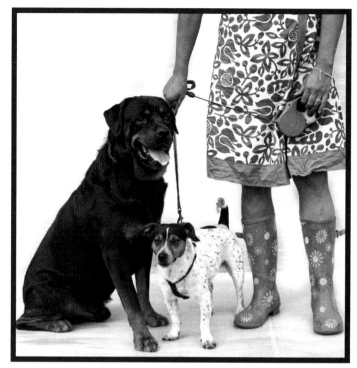

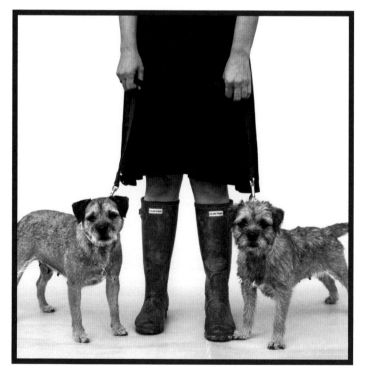

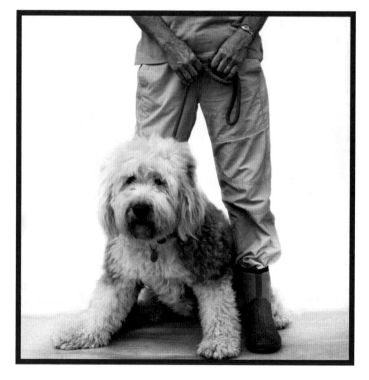

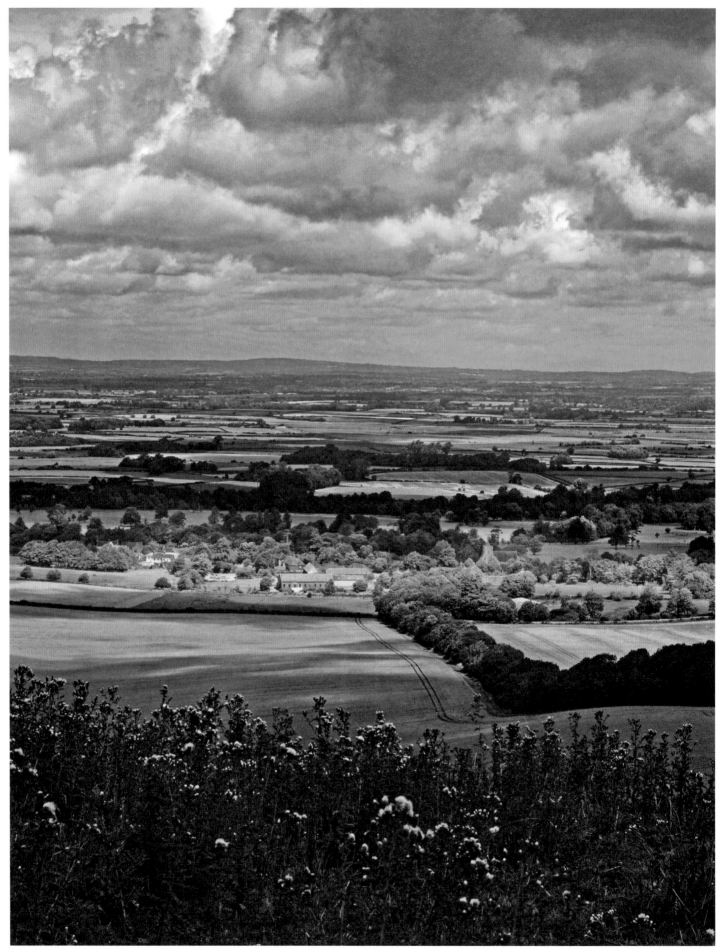

Firle village from the Downs.

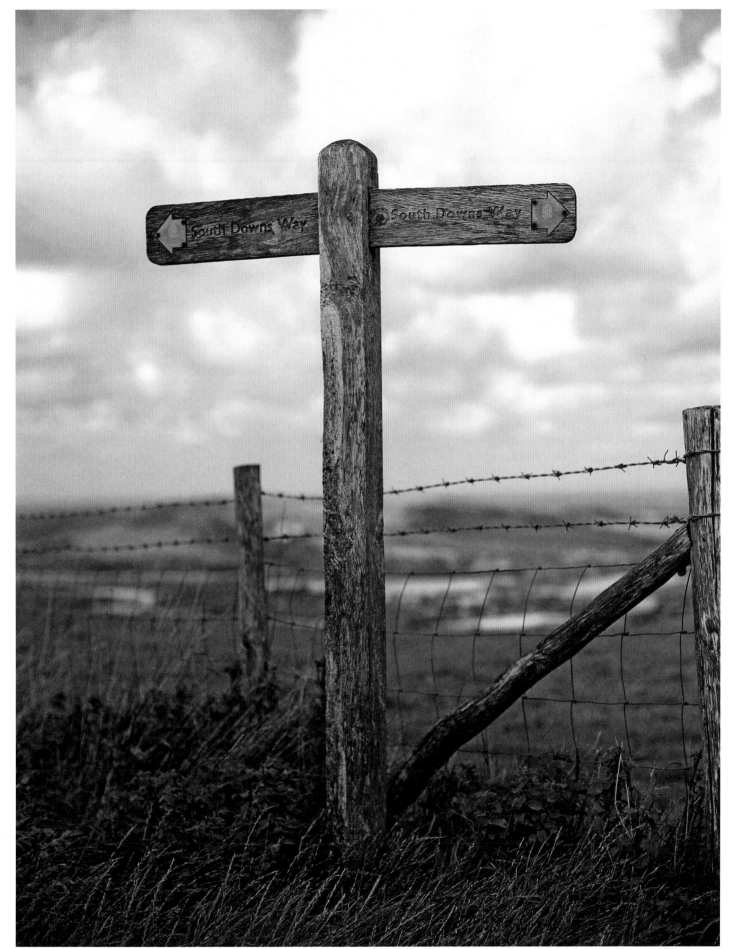

The South Downs Way follows old routes and droveways from Winchester to Eastborne, and passes close by the village.

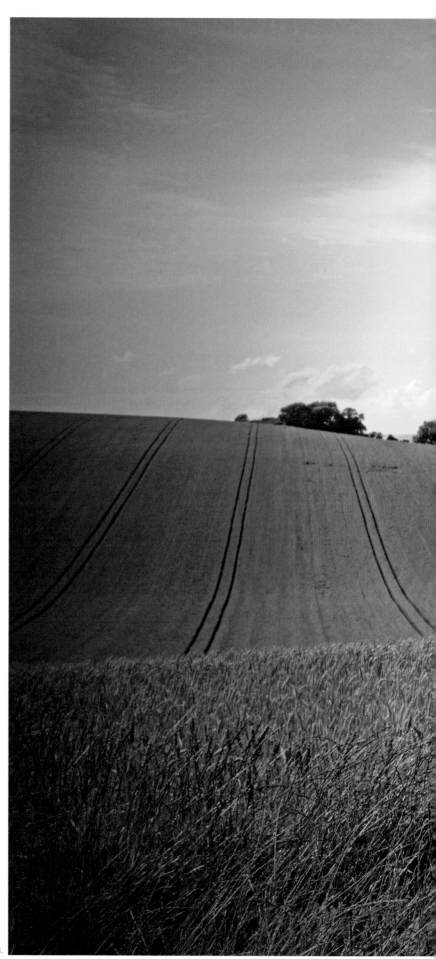

The Reverend Peter Owen Jones in his favourite surroundings.

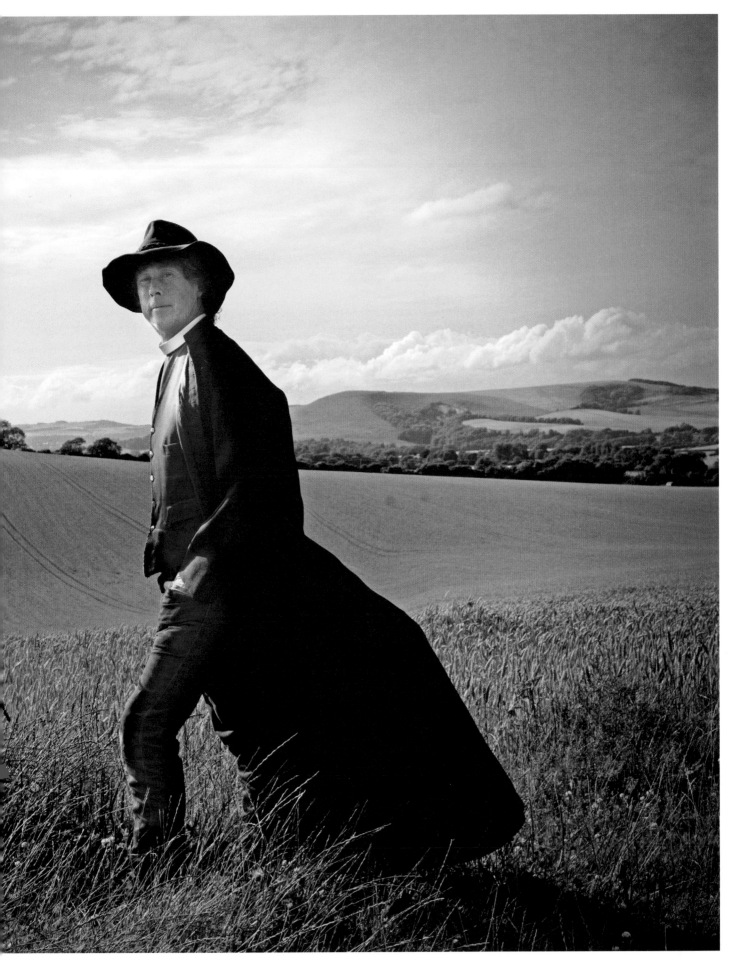

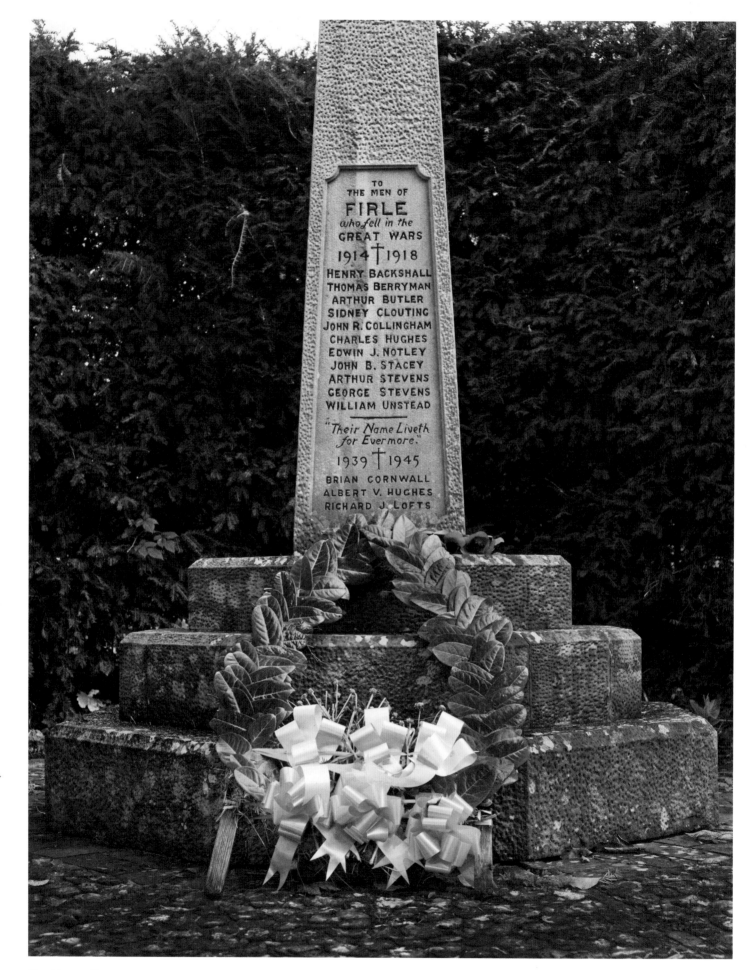

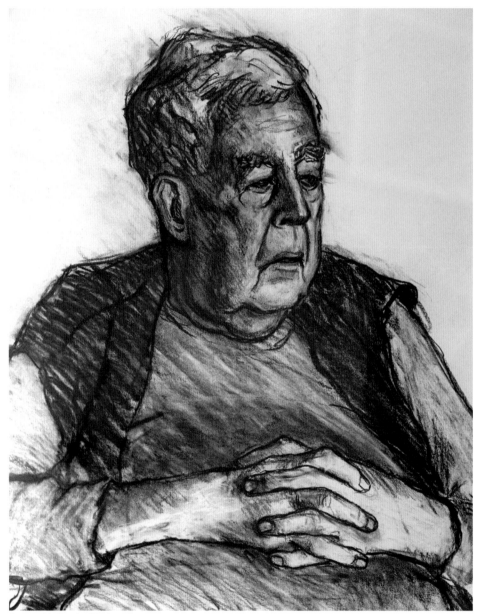

George Hufflett by Chelsea Renton.

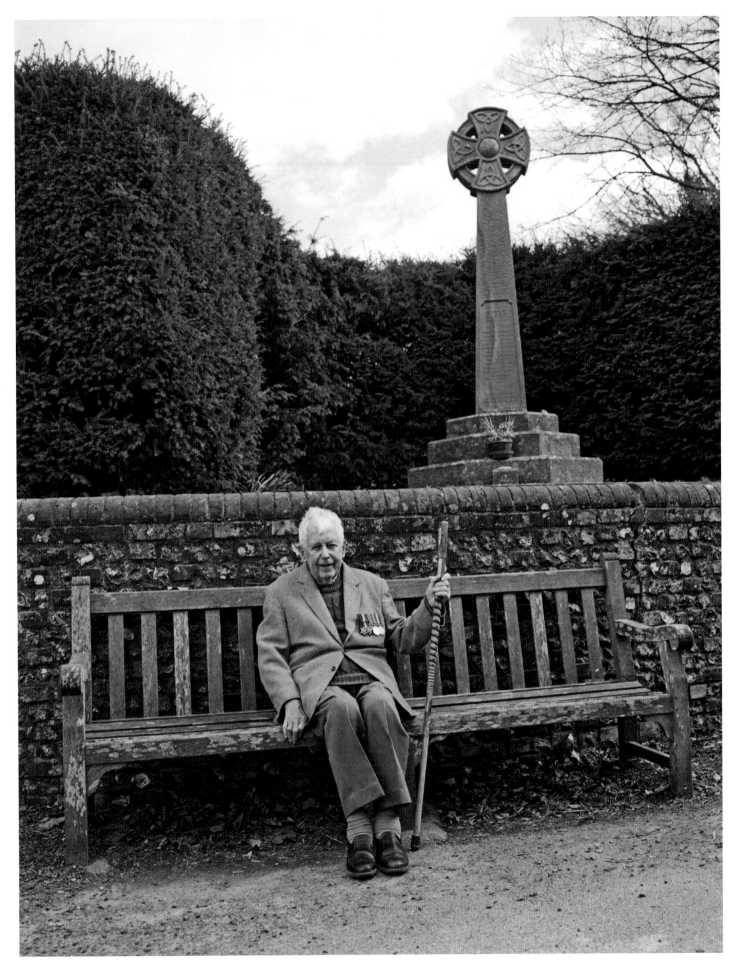

George's favourite seat.

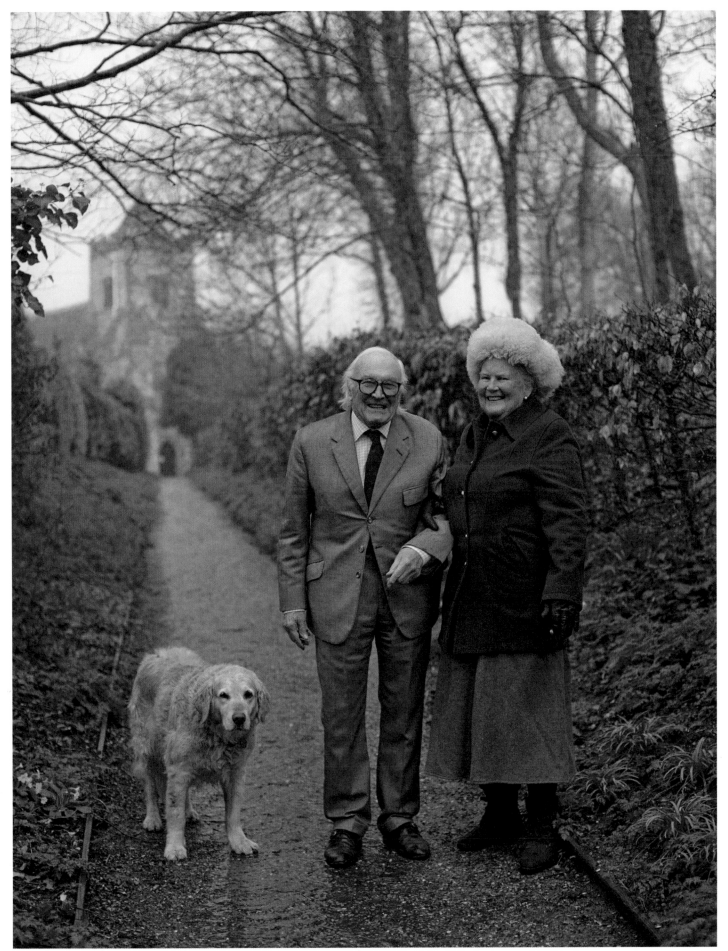

Mr and Mrs Barnes, former church wardens.

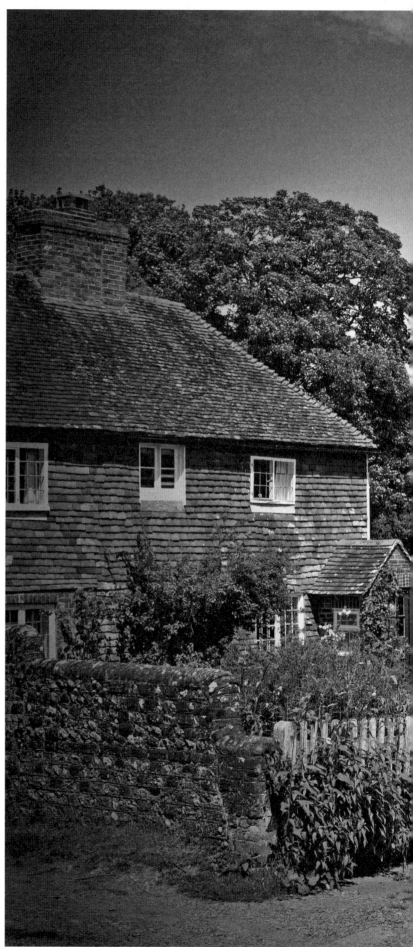

Riding down 'the dock'.

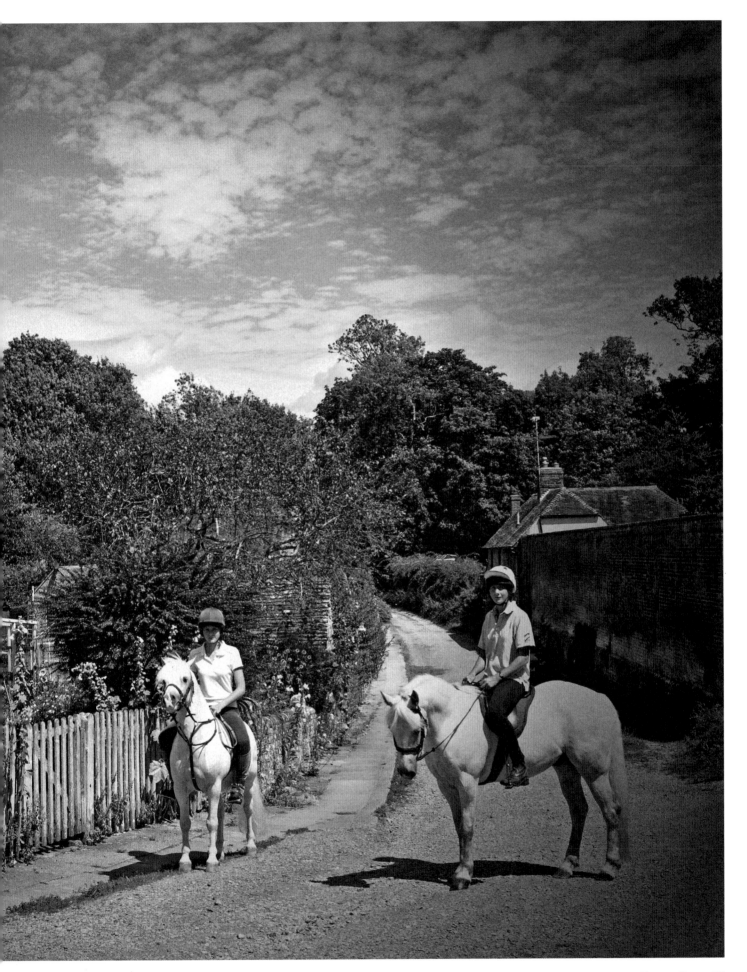

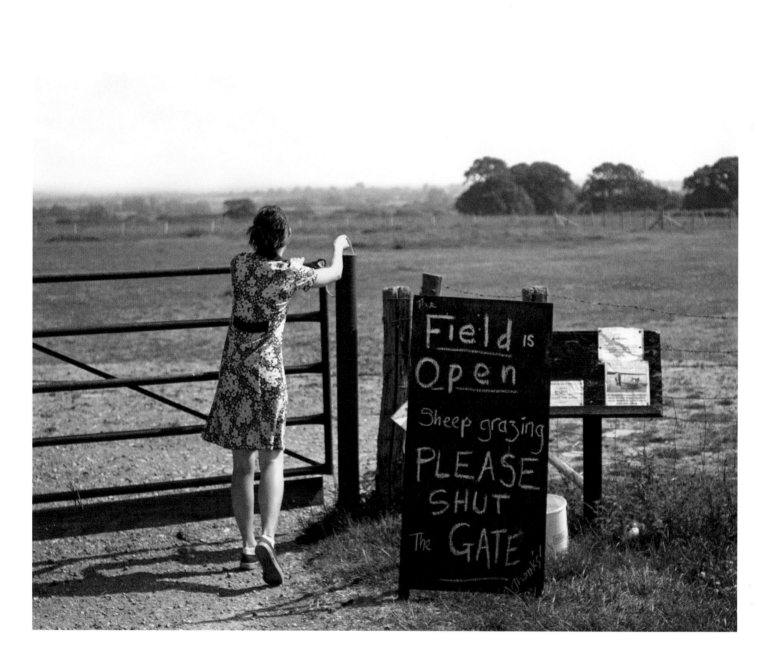

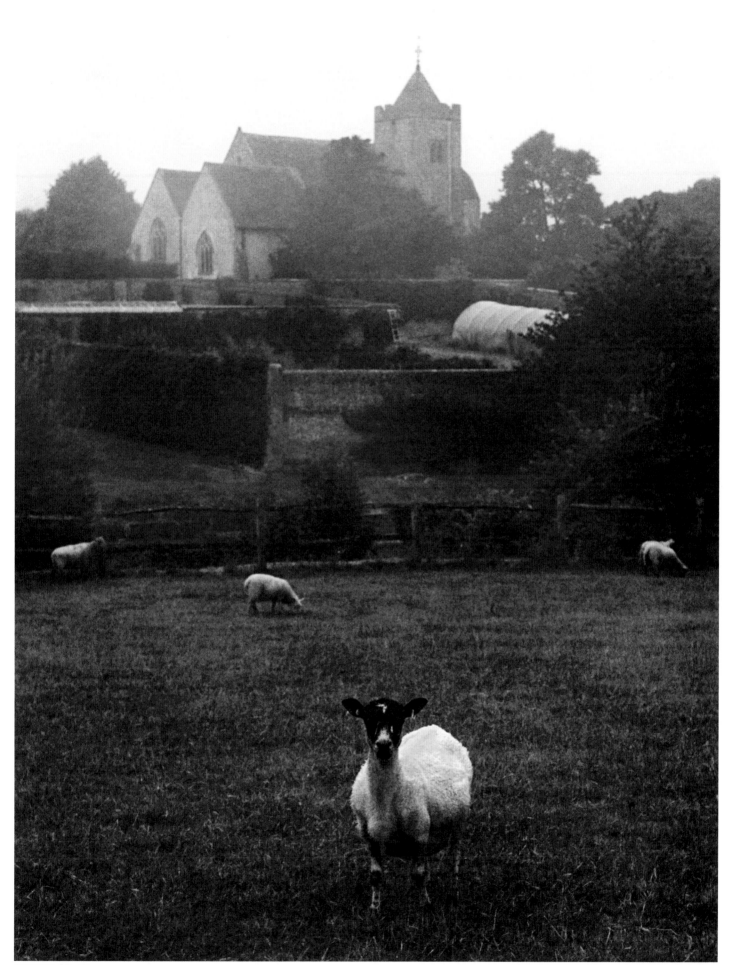

St Peter's Church.

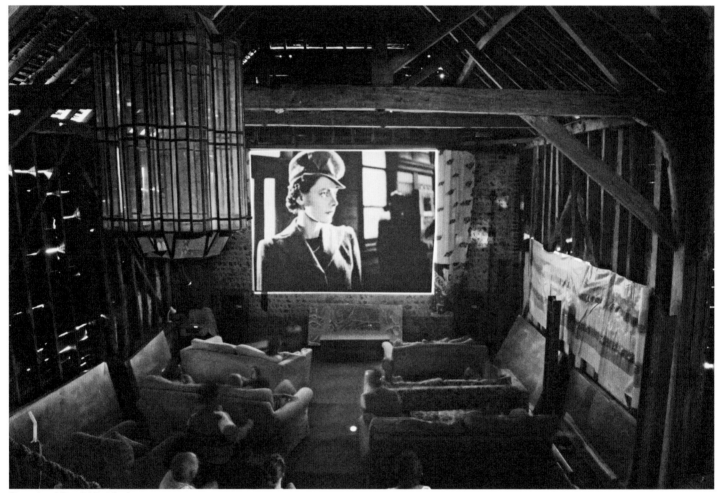

Occasional film night at the barn.

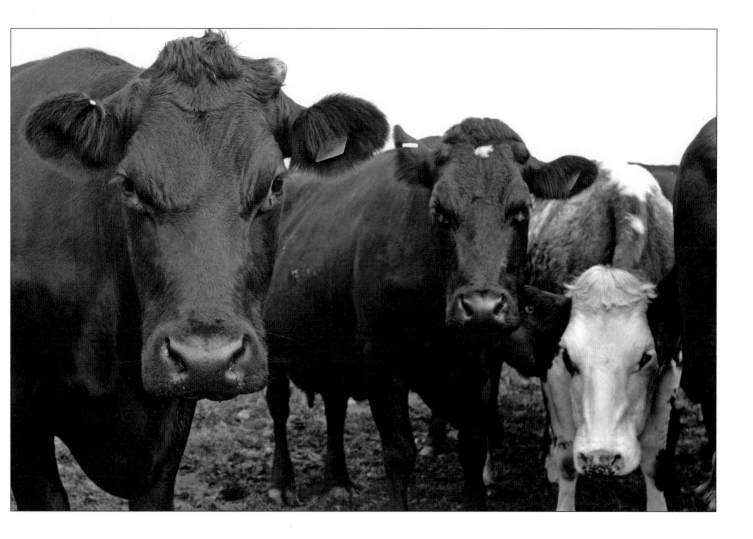

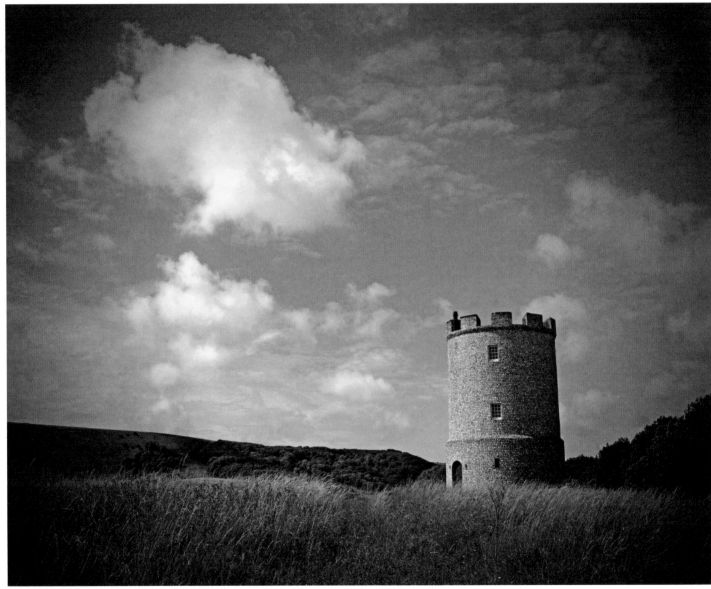

The Tower.

Middle Farm home brew.

Helen and Rod Marsh of Middle Farm with their rooster Francis. They hold the largest collection of perry and ciders in the UK.

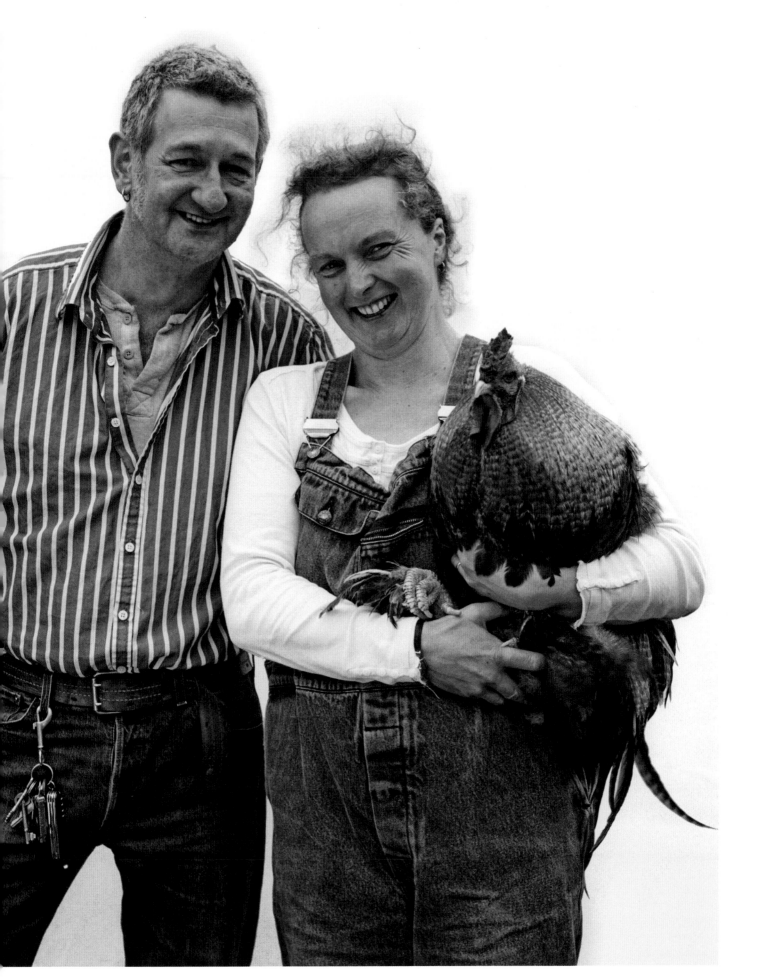

Sophie Coryndon paints the new pub sign for The Ram.

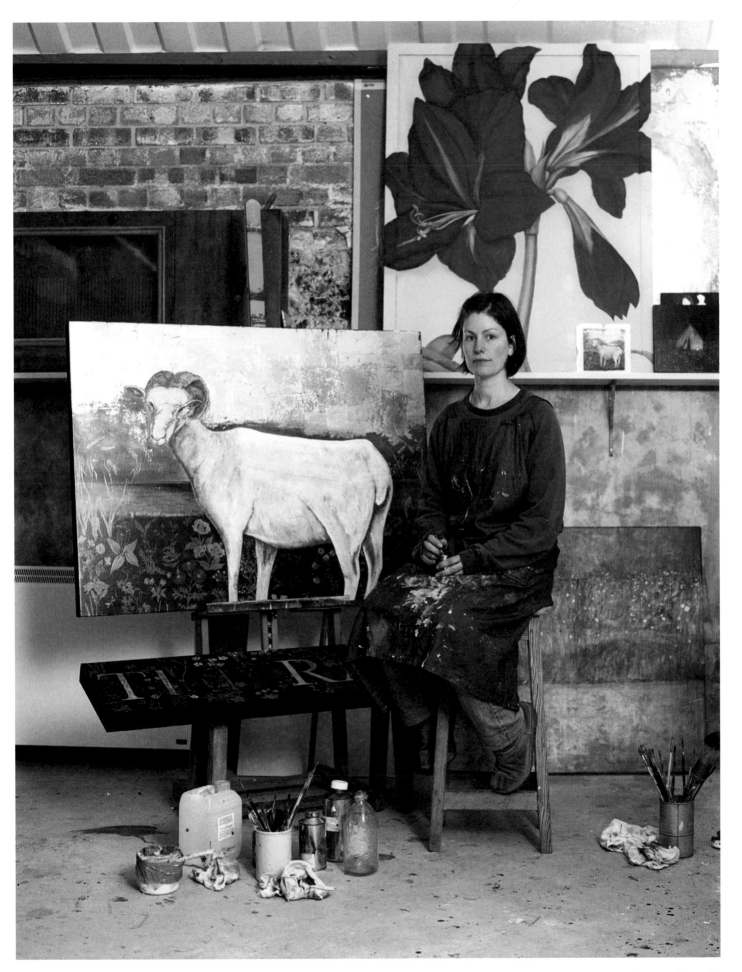

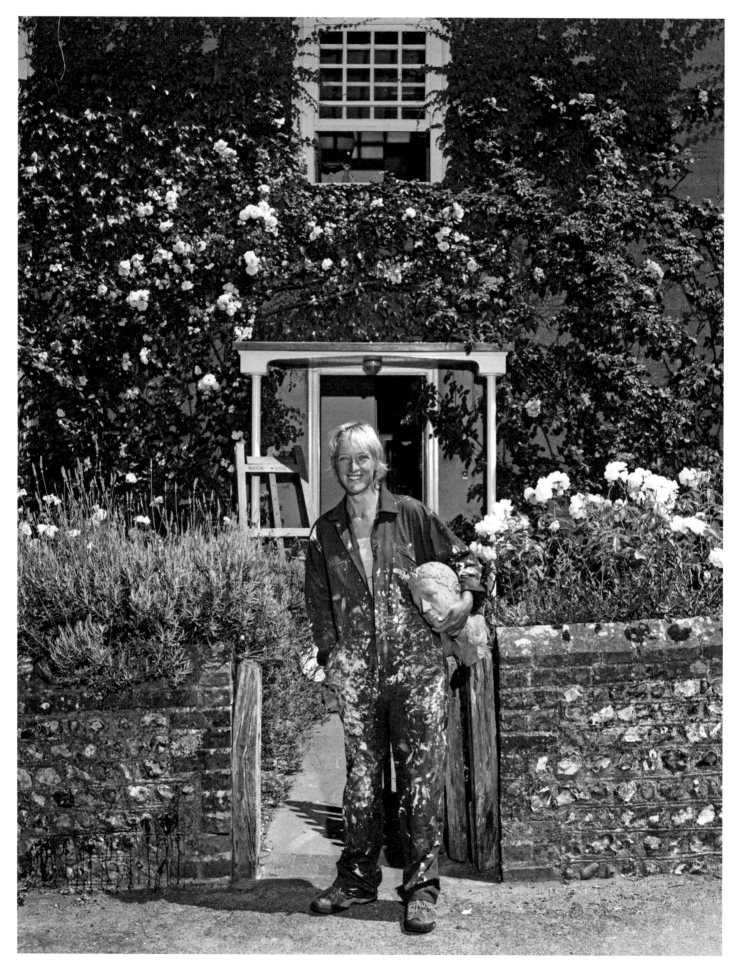

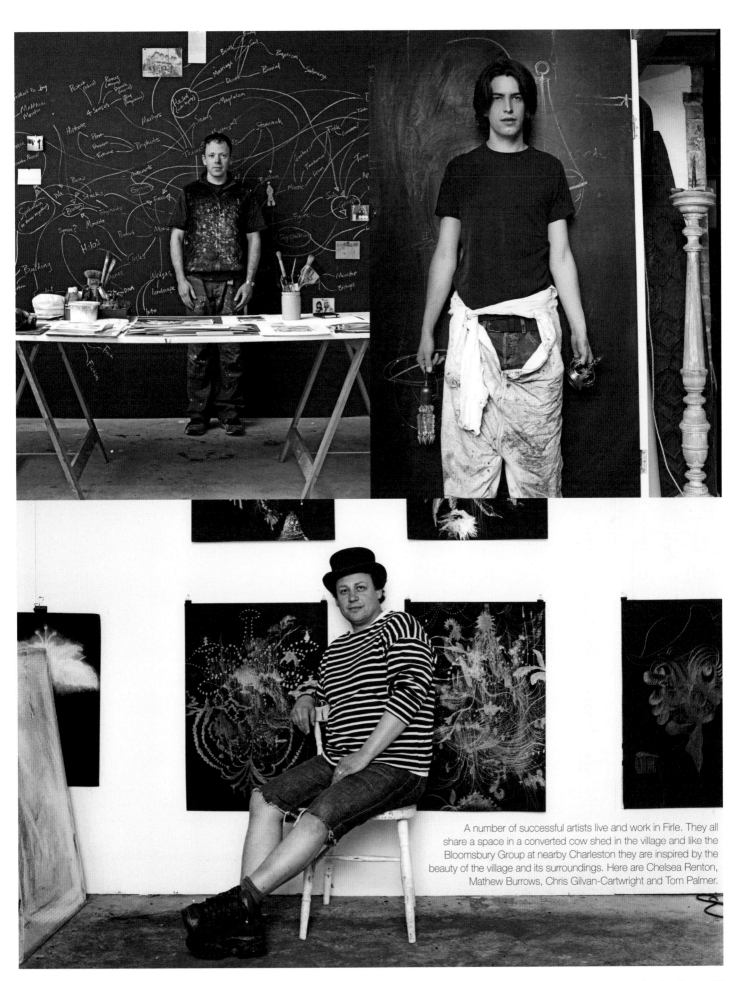

A number of successful artists live and work in Firle. They all share a space in a converted cow shed in the village and like the Bloomsbury Group at nearby Charleston they are inspired by the beauty of the village and its surroundings. Here are Chelsea Renton, Mathew Burrows, Chris Gilvan-Cartwright and Tom Palmer.

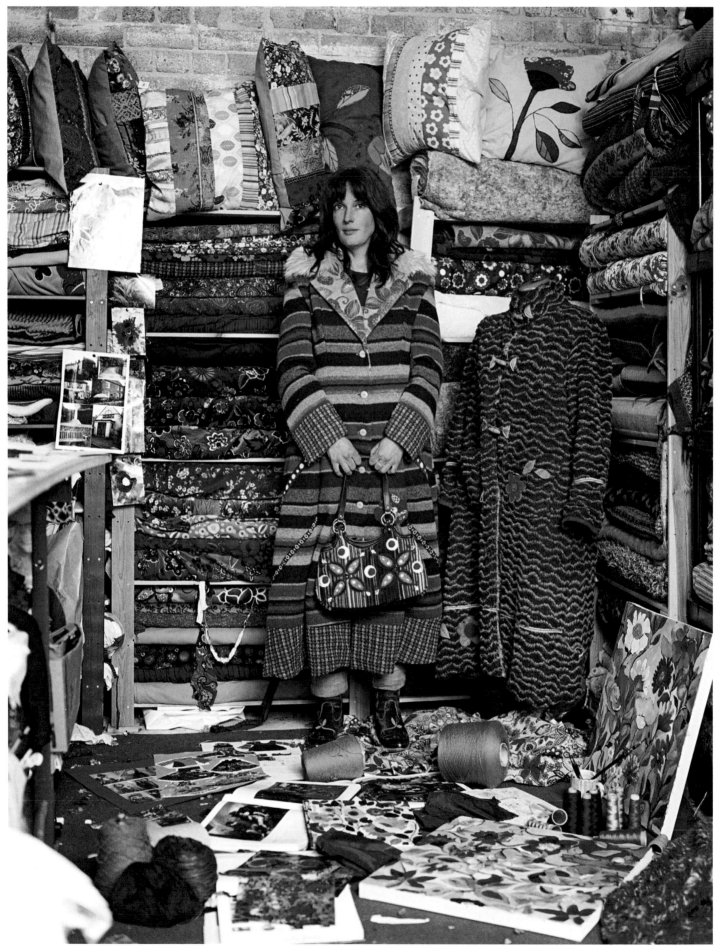

Carola van Dyke, designer, artist, mother.

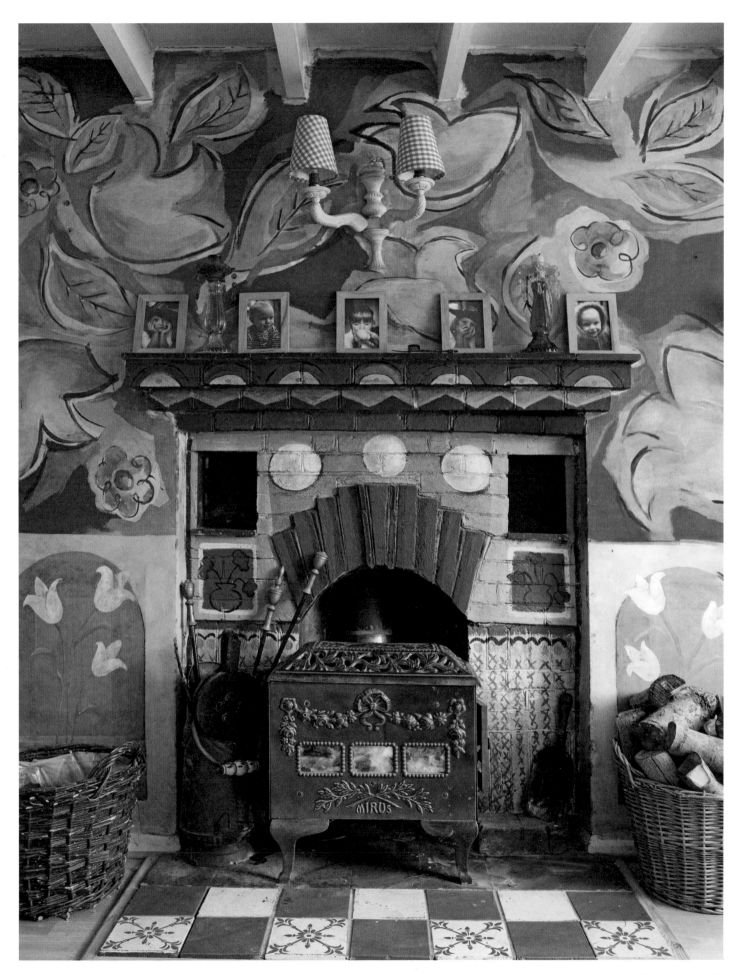

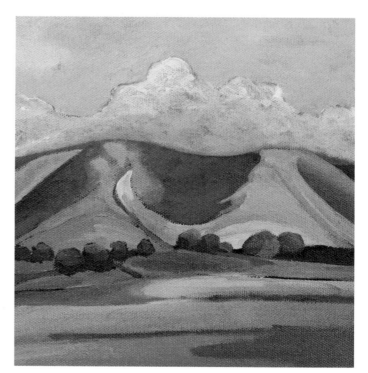

A walk through the village in acrylics by Carola van Dyke.

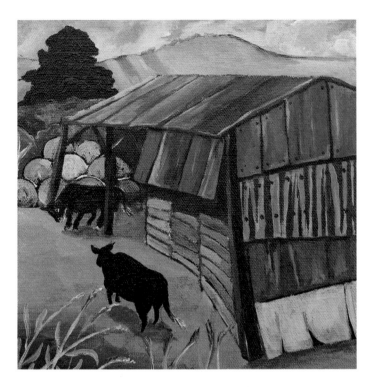

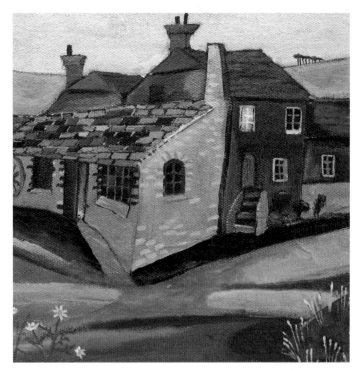

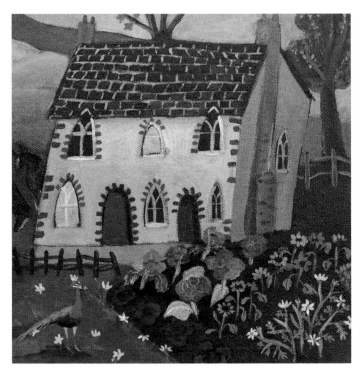

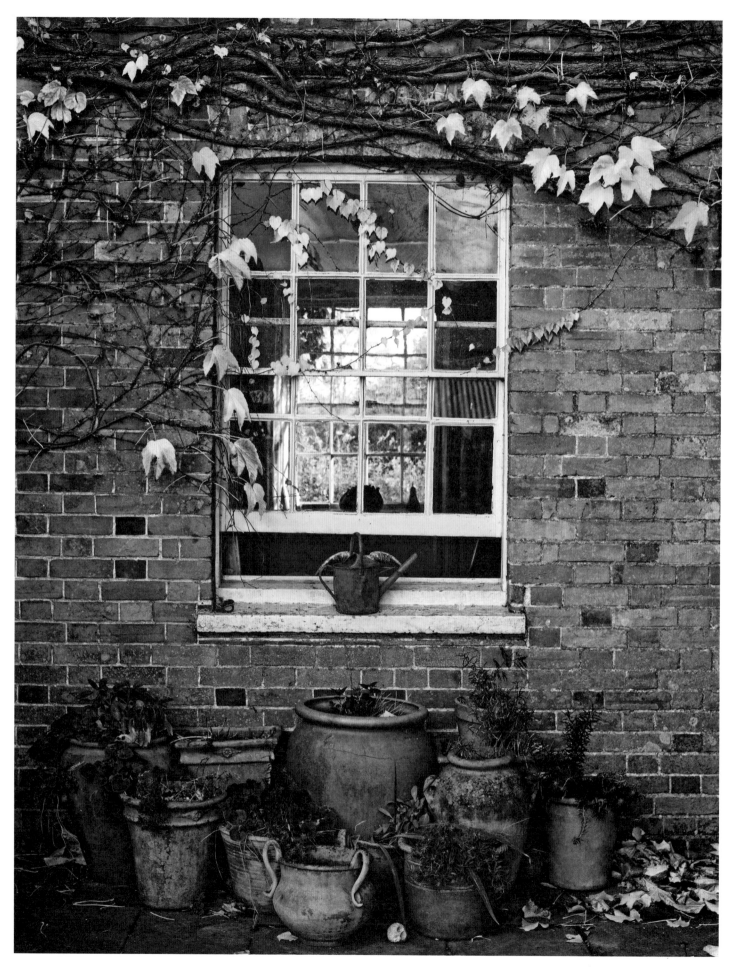

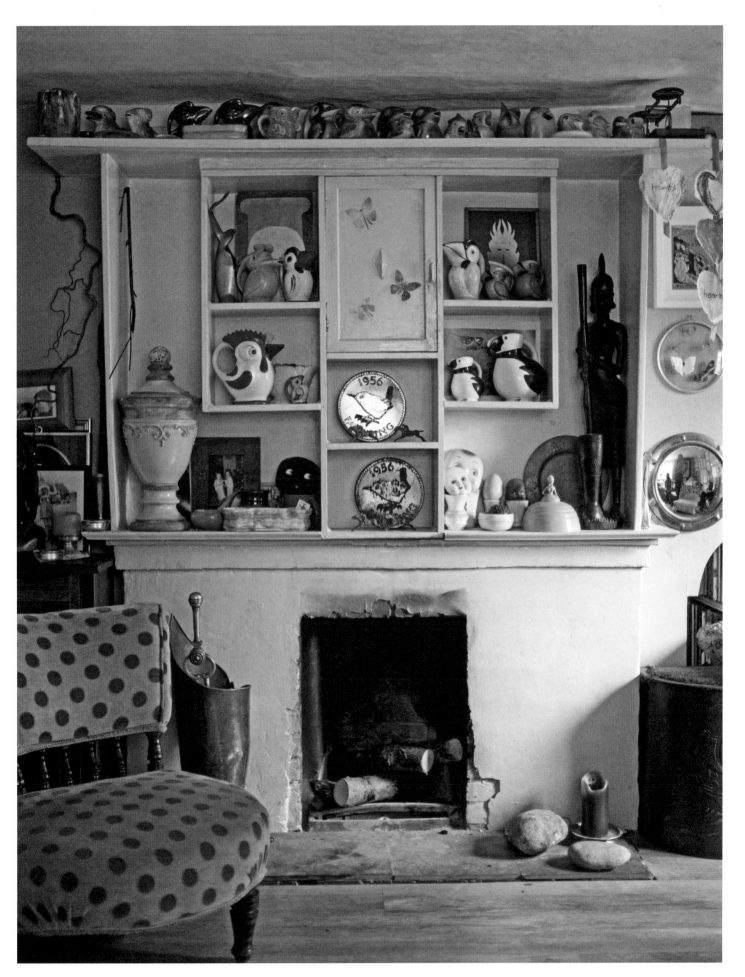

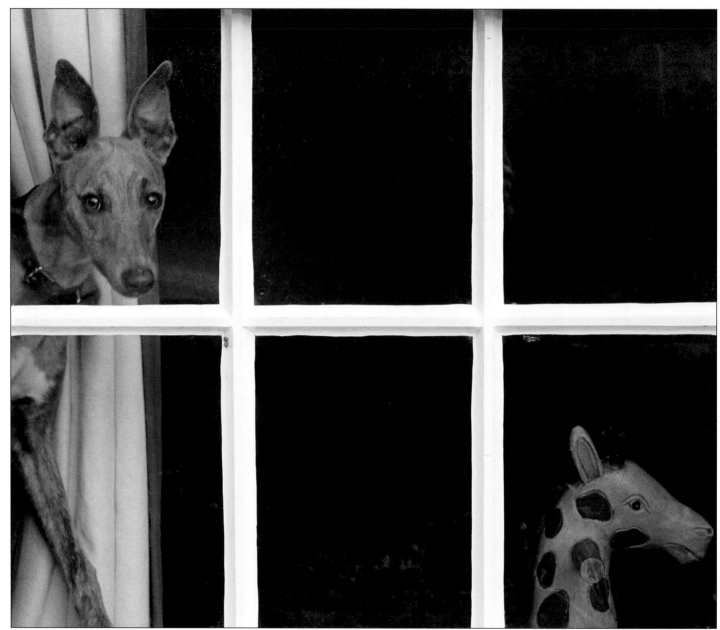

Johnny 5 the whippet.

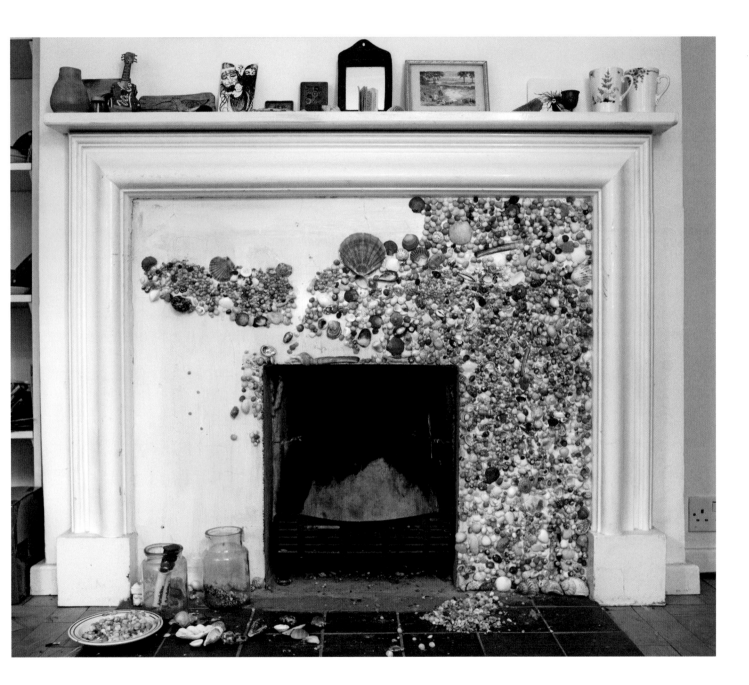

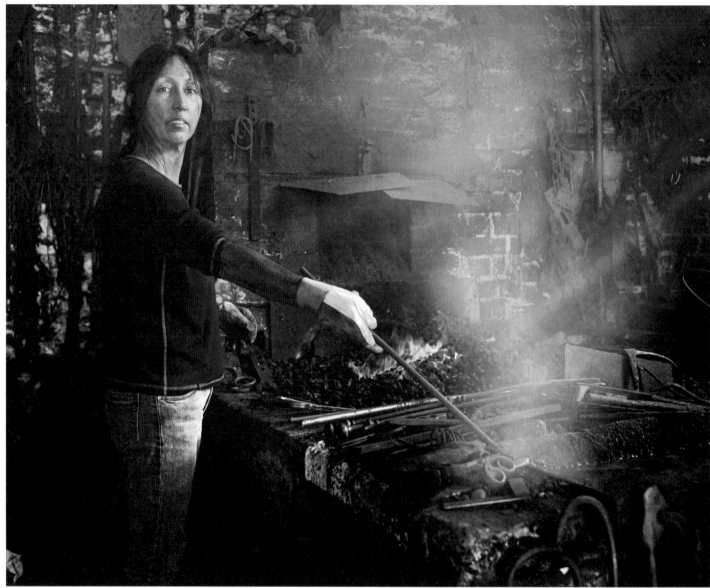

Lorraine Phillpott, artist blacksmith.

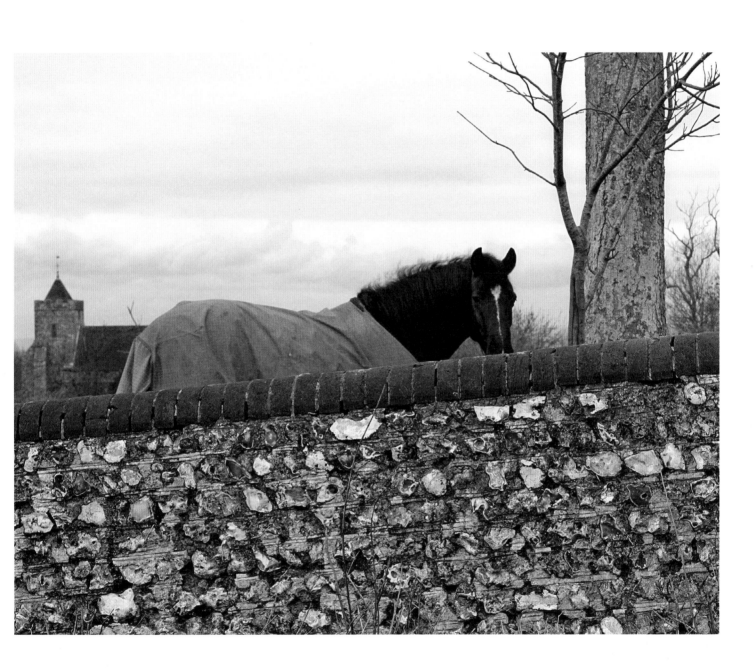

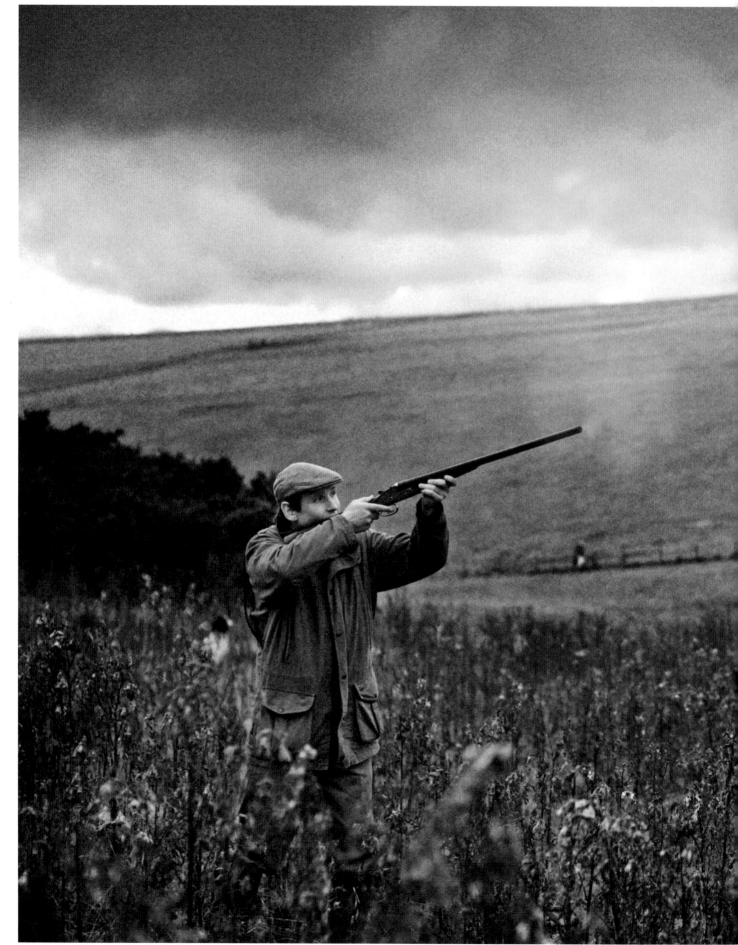

Tom Gribble, Firle farmer.

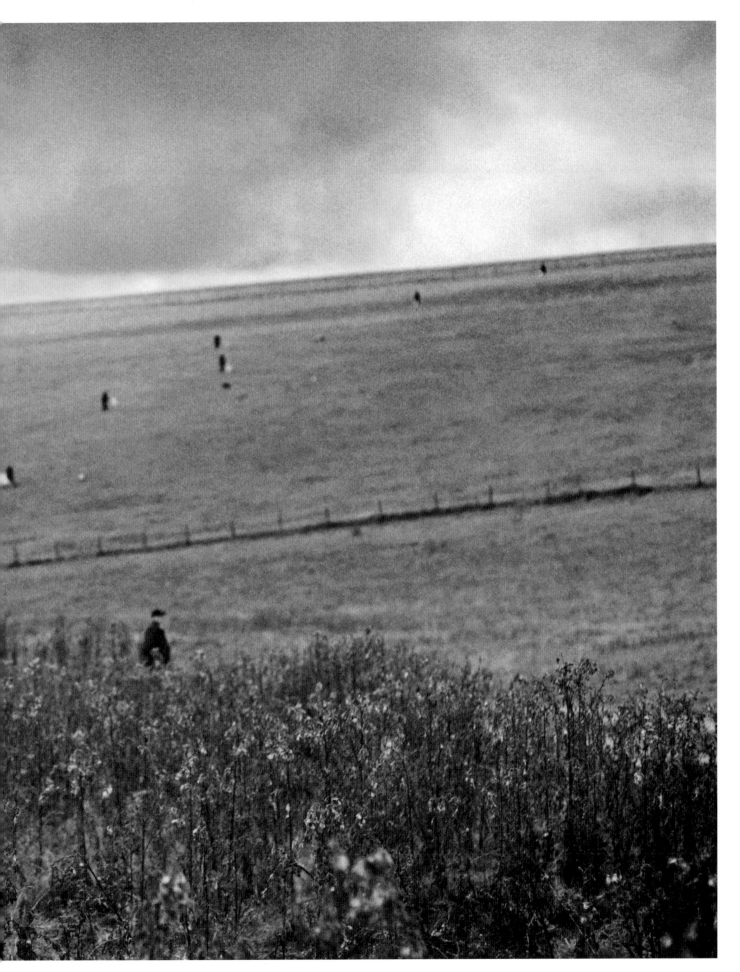

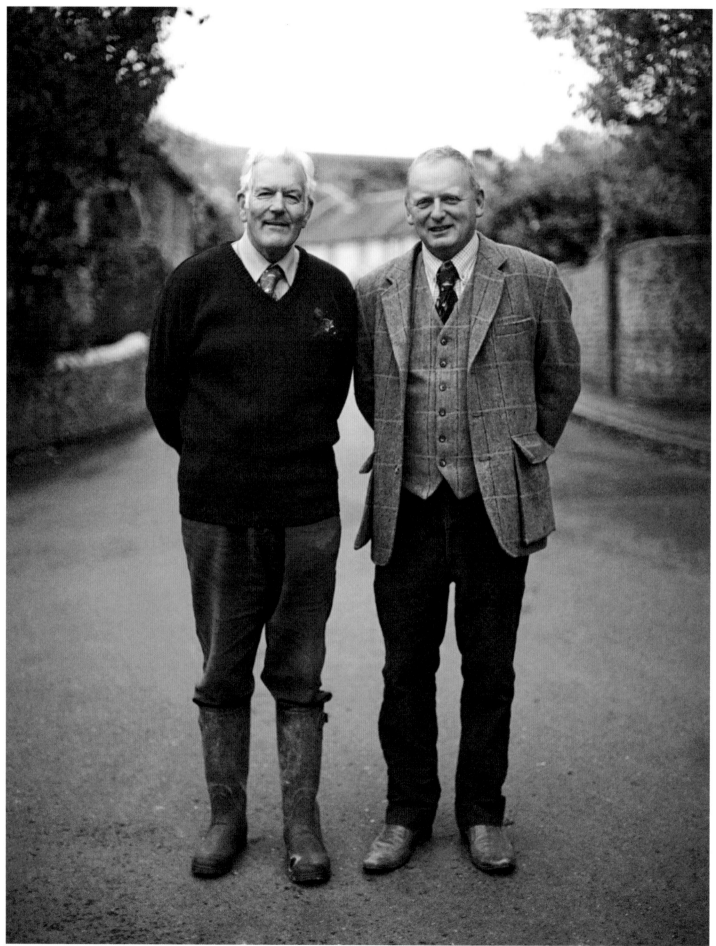

Bill and David, former and present gamekeepers.

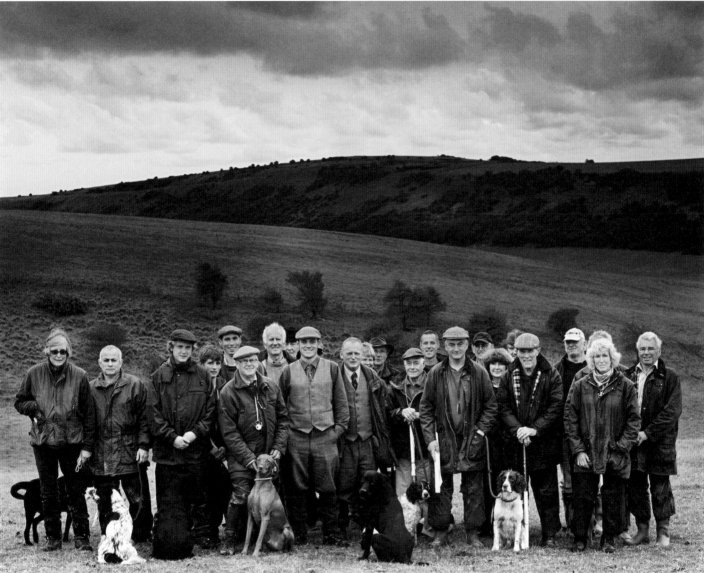

Pheasant shoot beaters.
Pages 102–3: Tosh, a gun dog.

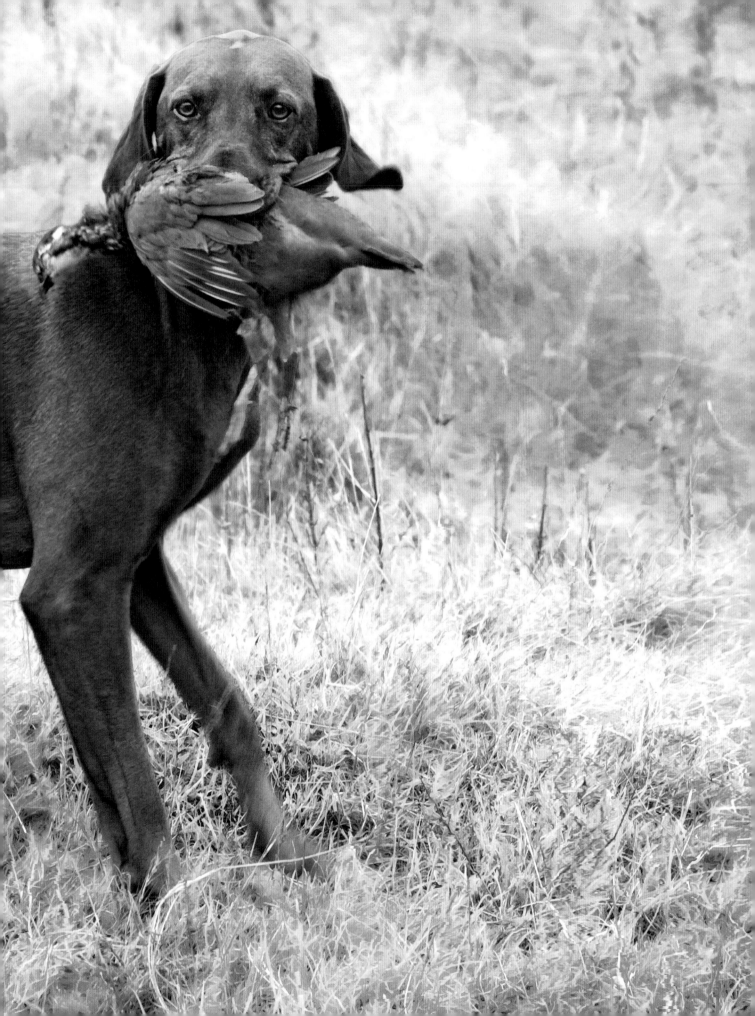

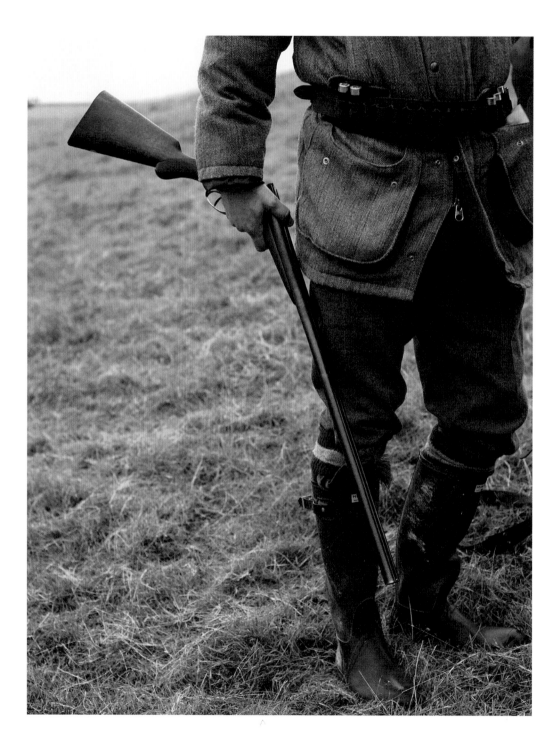

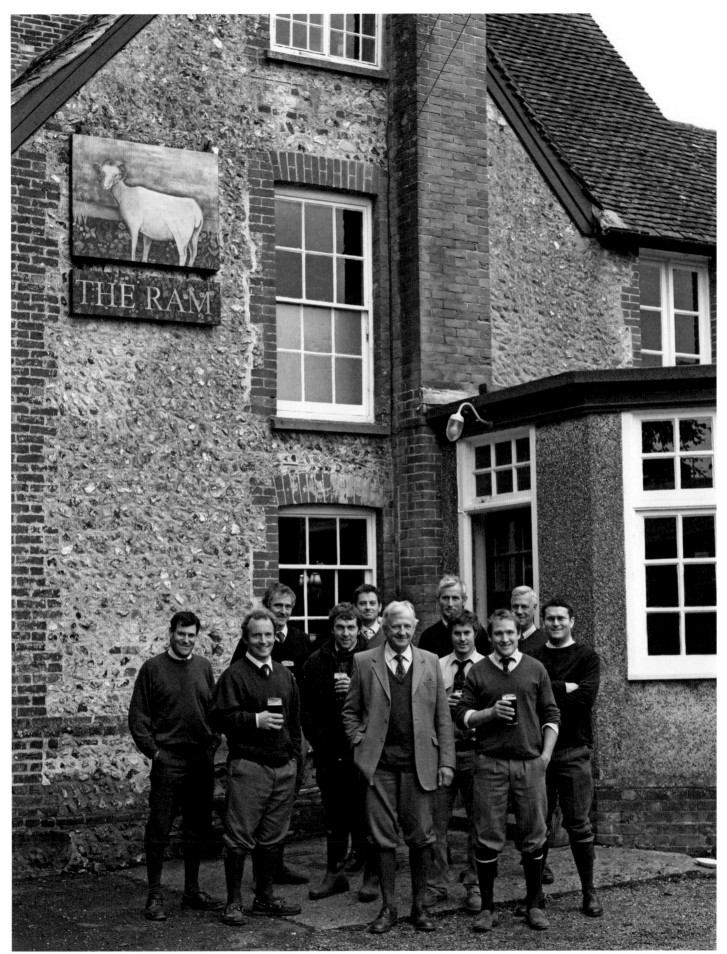

The local farmers.

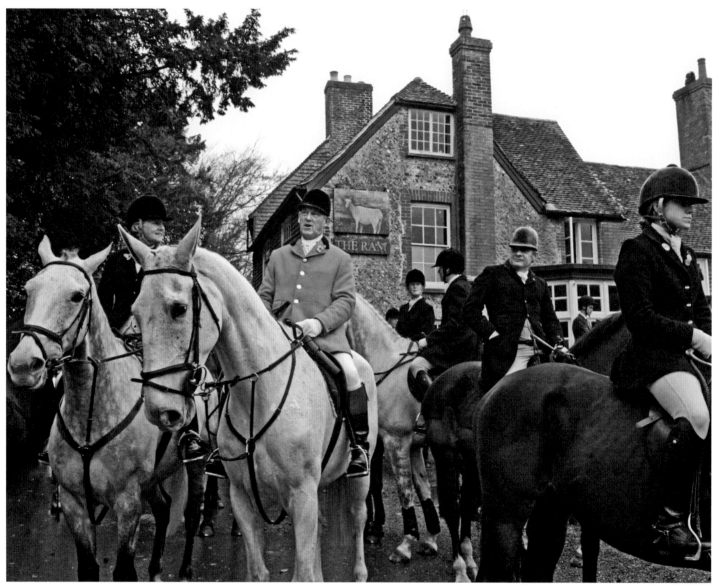

The October meet.

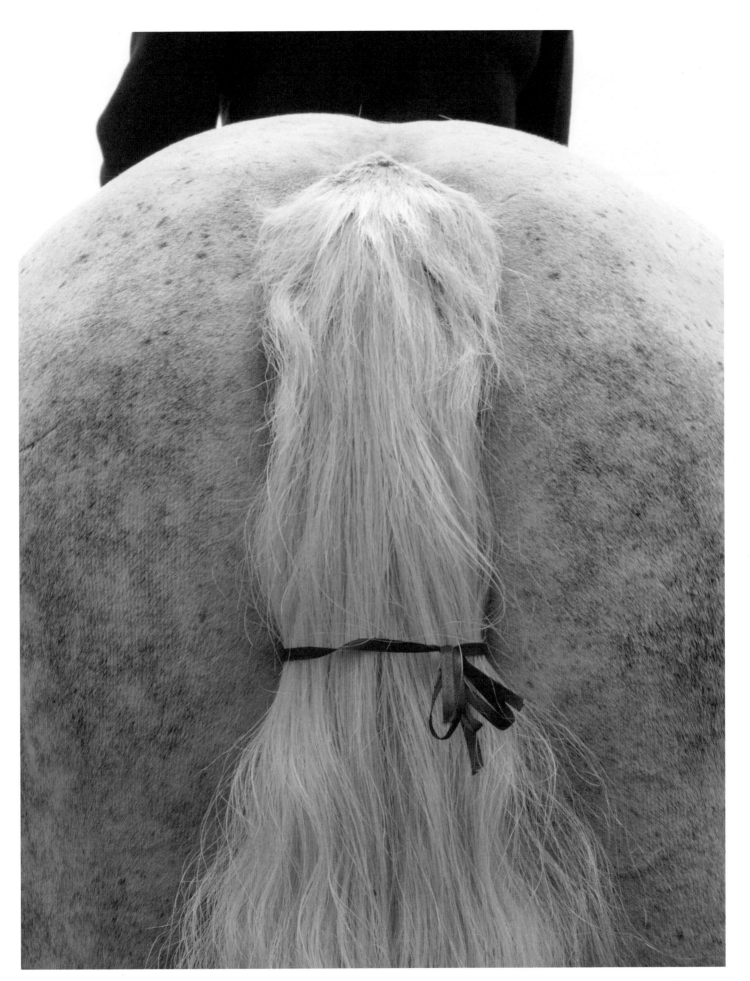

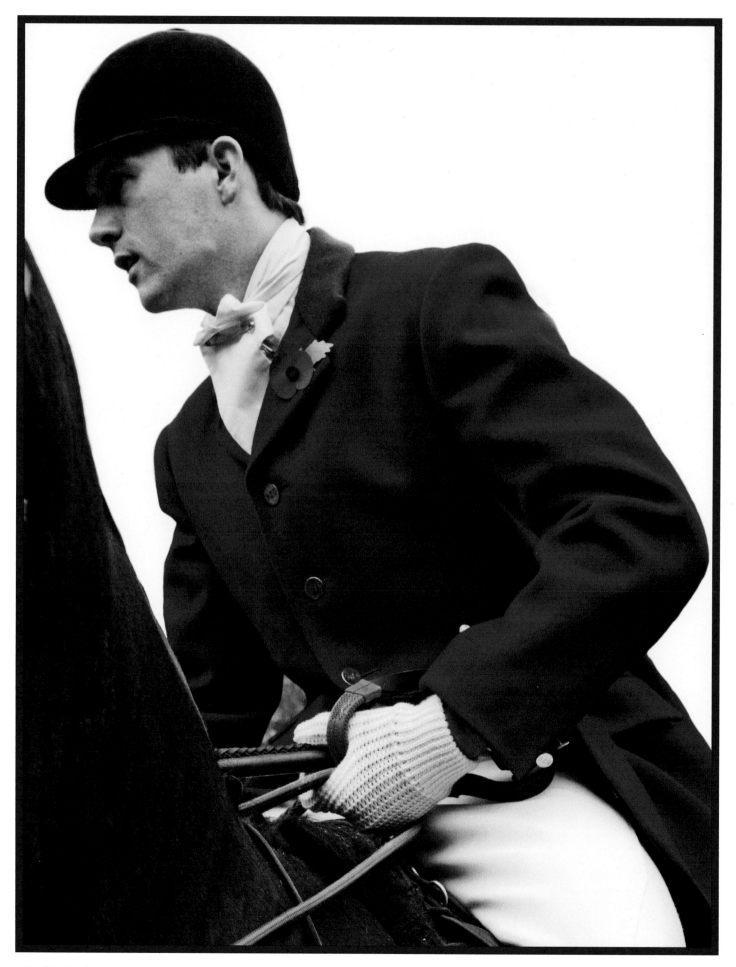

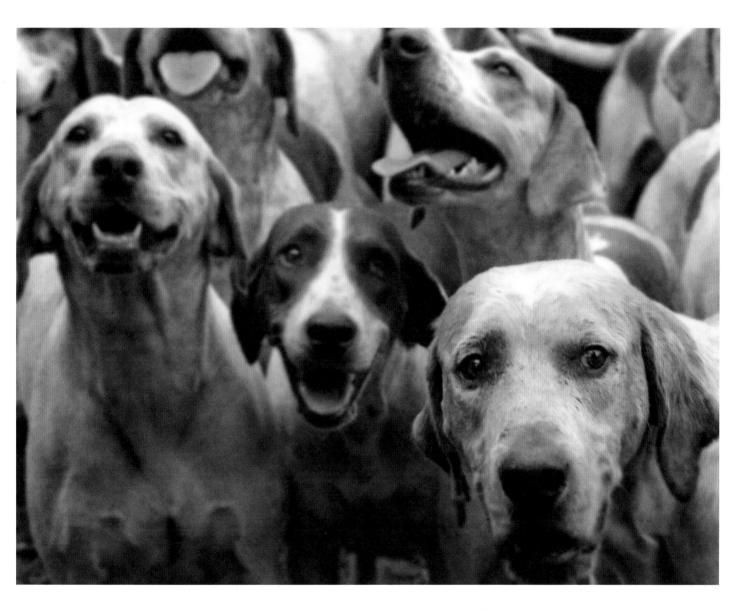

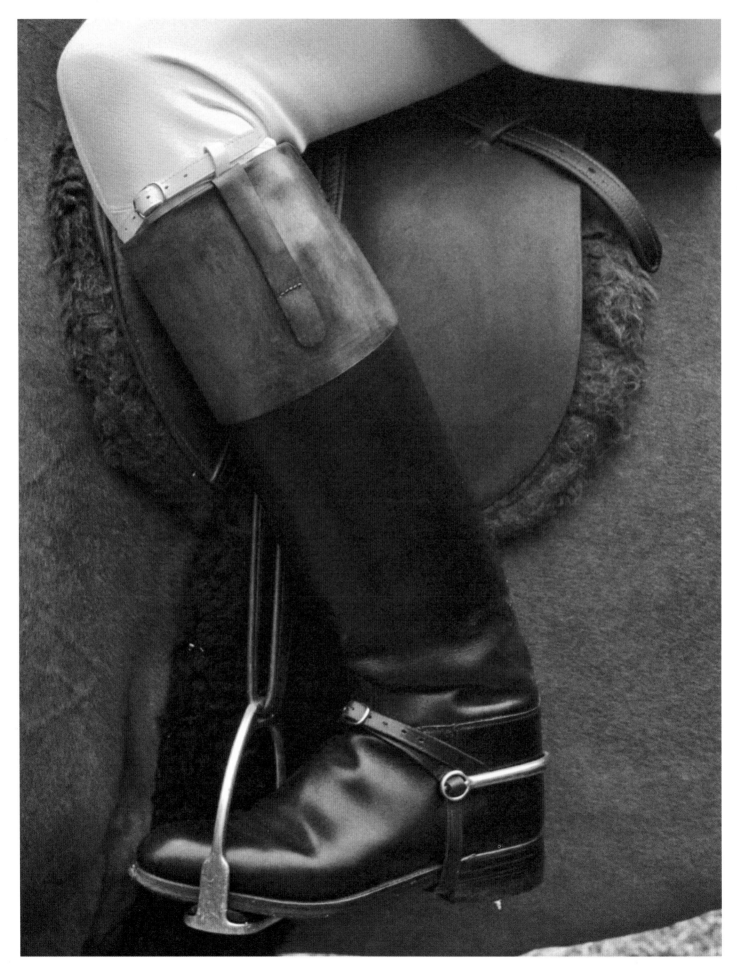

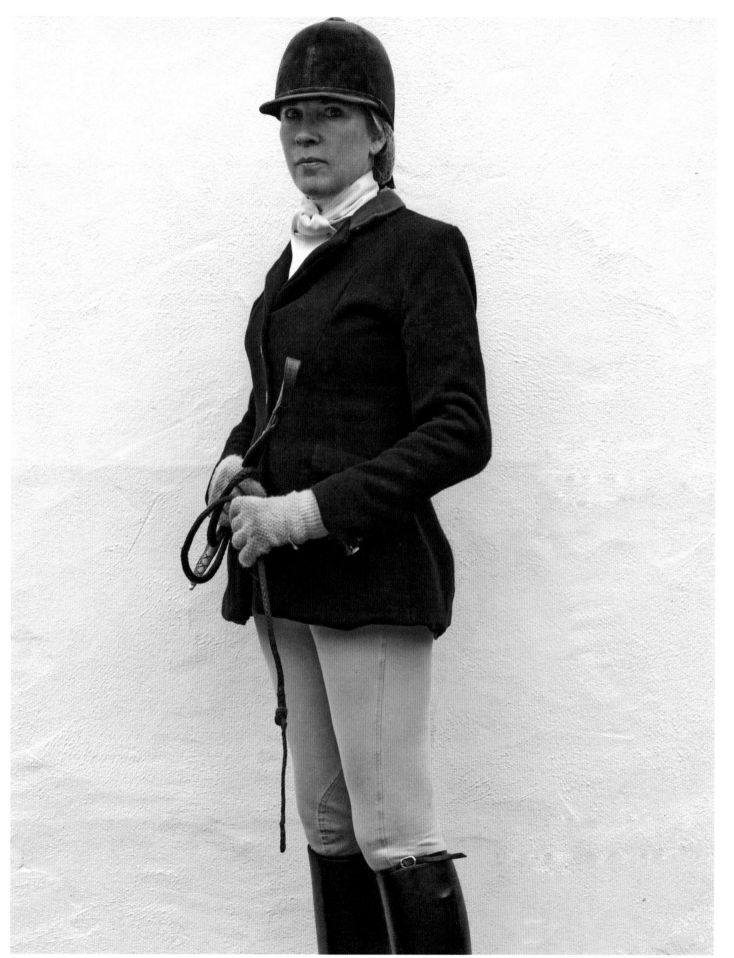

Caroline Fuller, caterer.

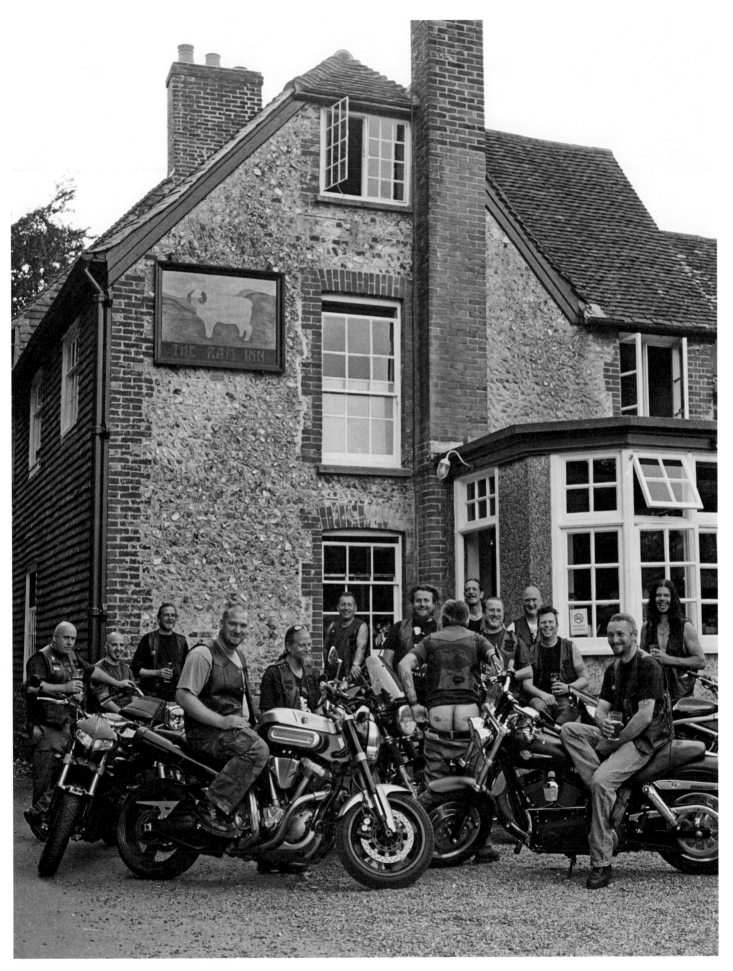

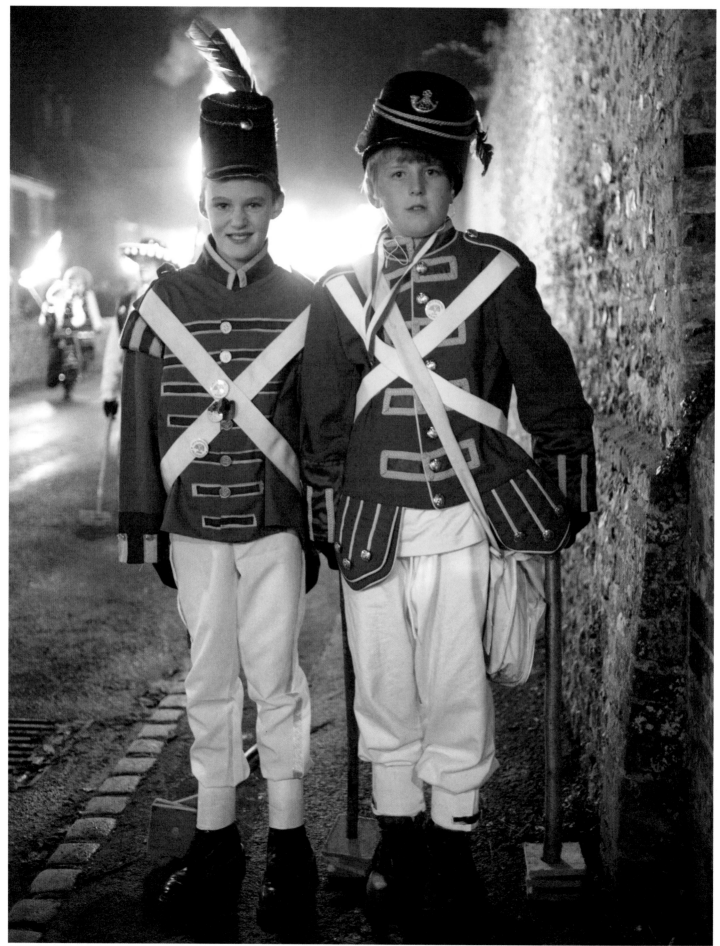

A traditional village bonfire night.

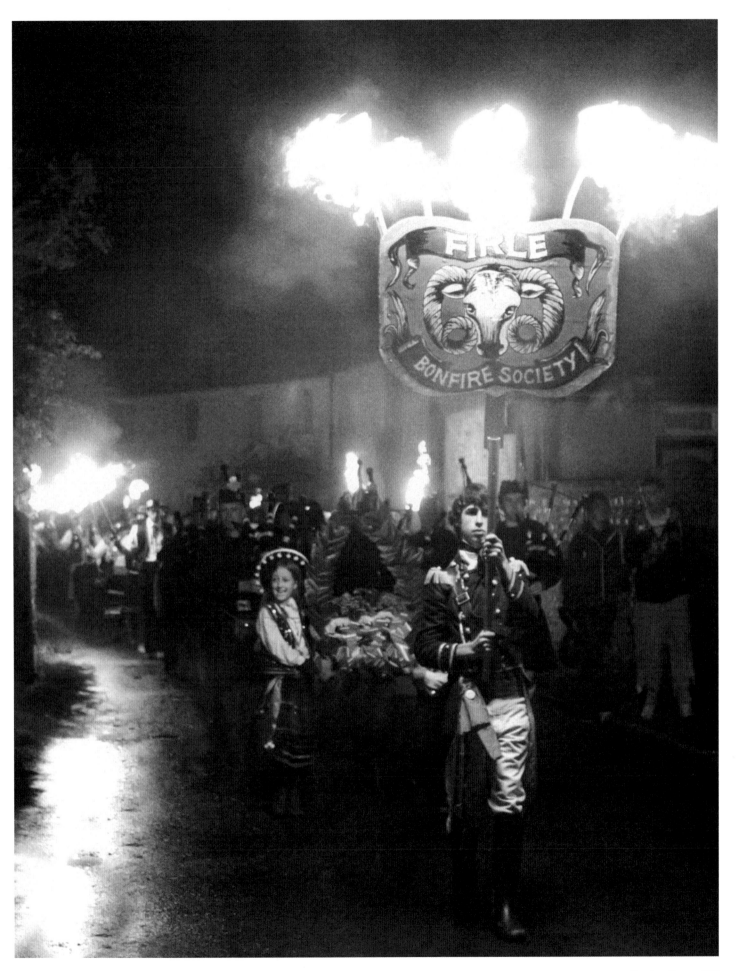

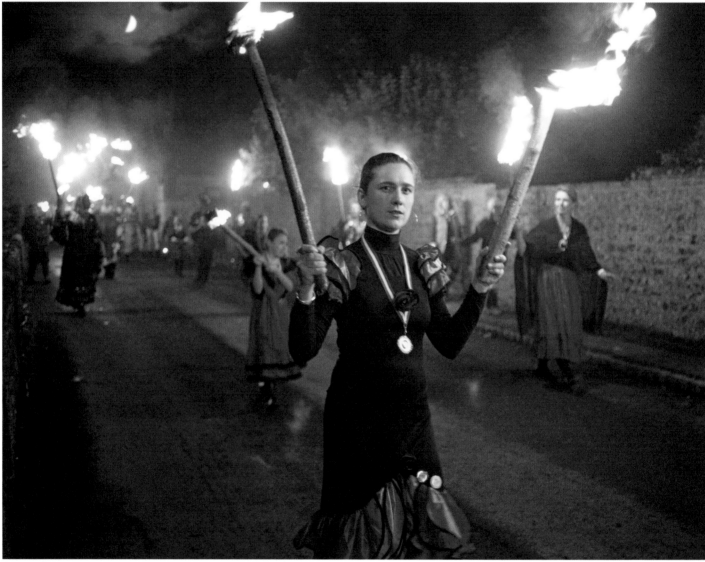

Clare, a 'Spanish Lady', events production manager and school choir mistress.

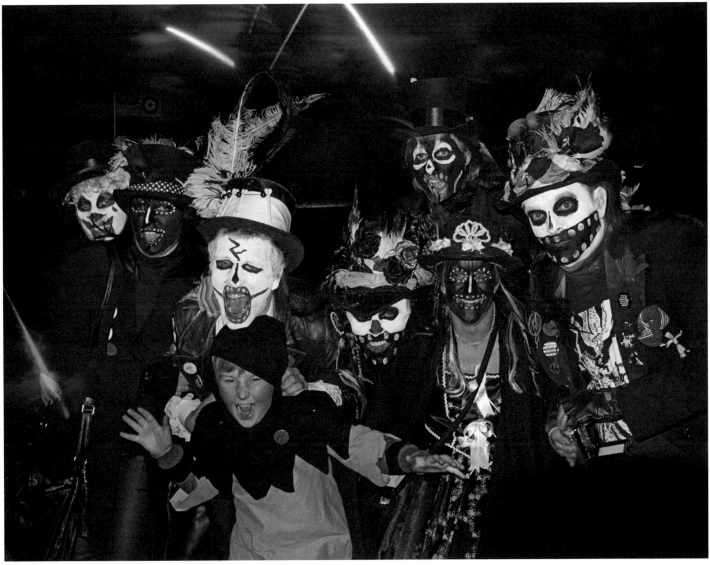
'Blackjacks' on bonfire night.

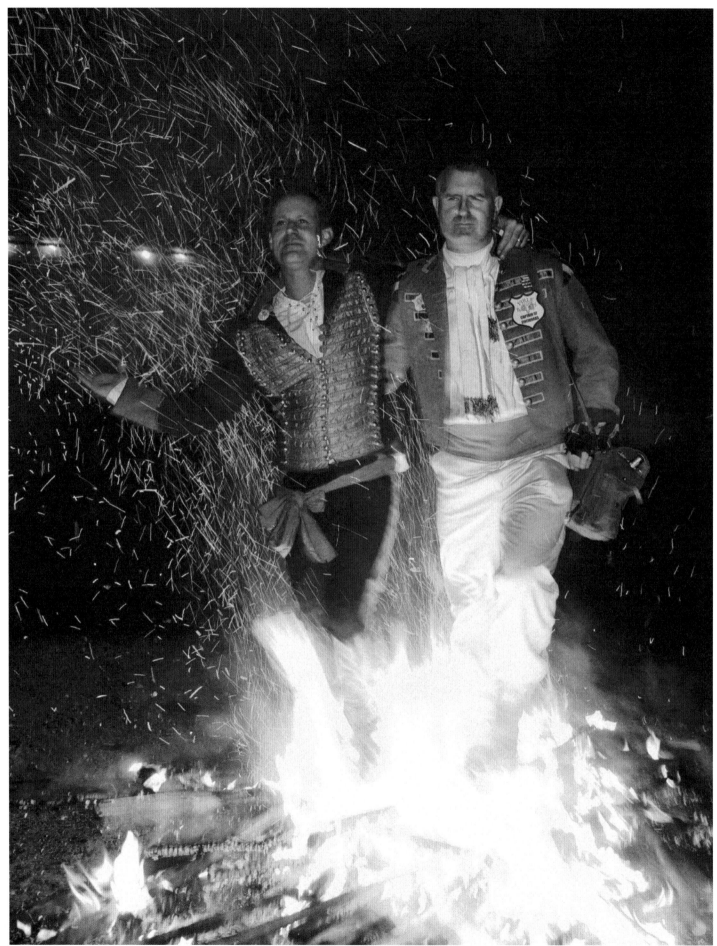
Leaping the fire, a bonfire night tradition.

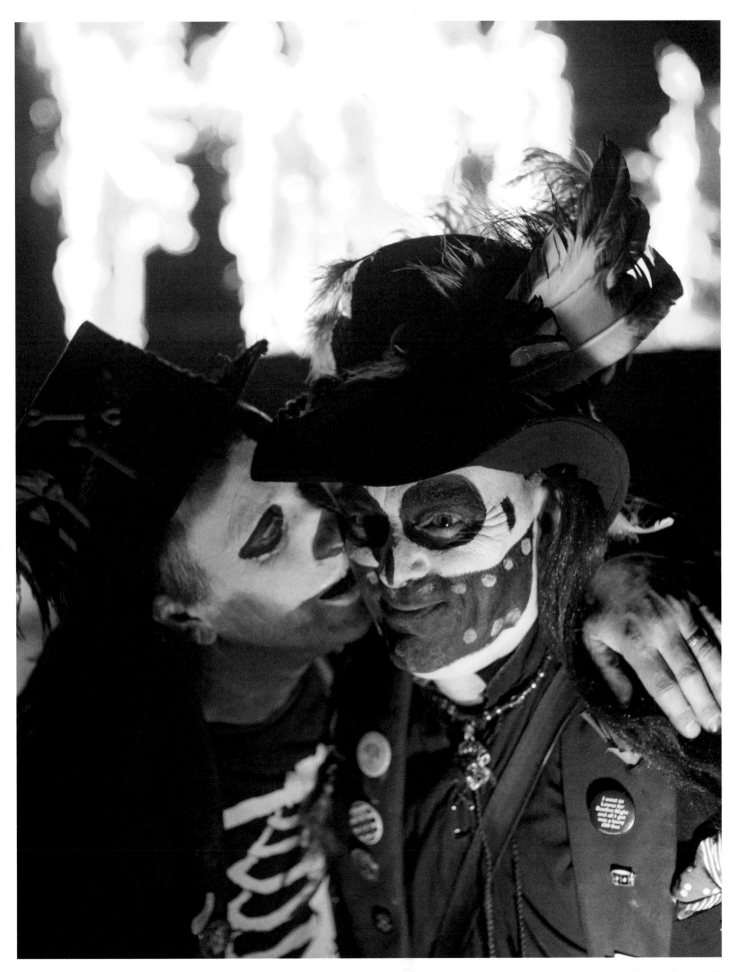

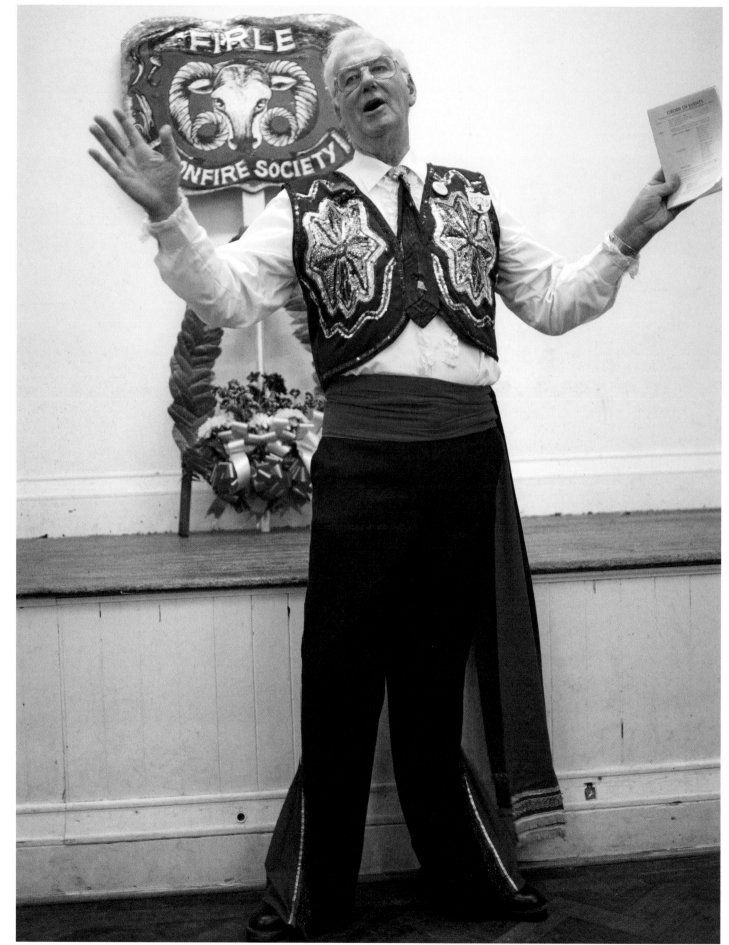

Ray Gravett, vice president of the bonfire society.

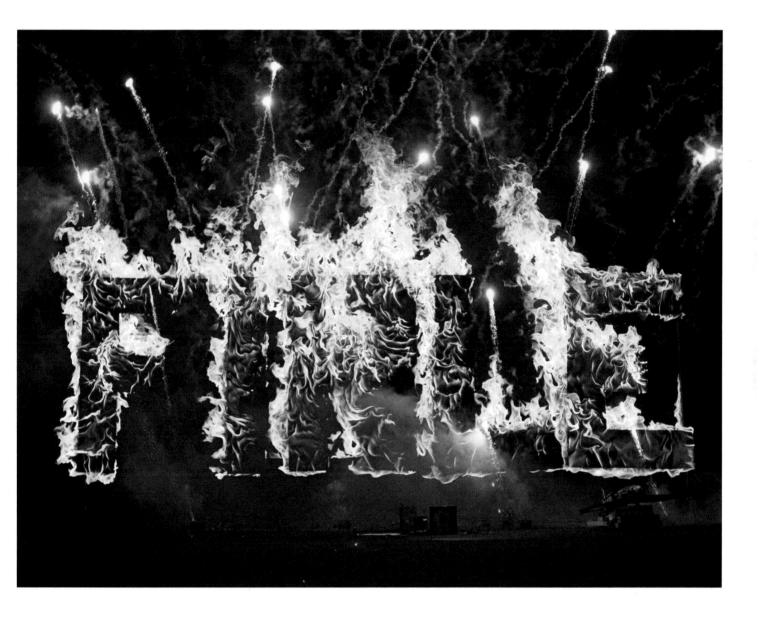

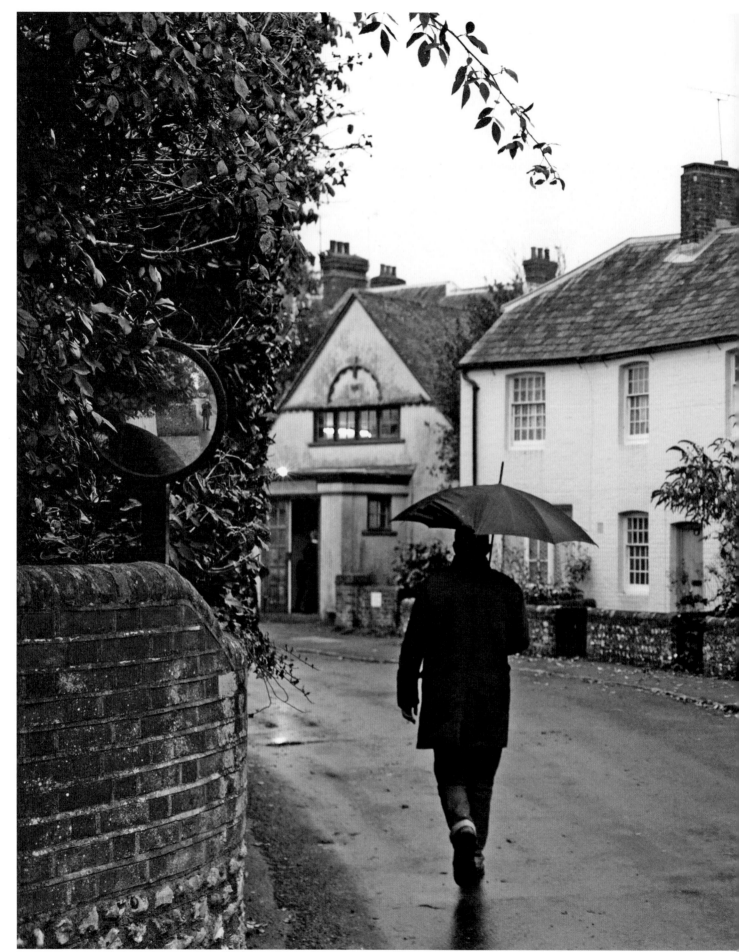

The Street runs from the beginning to the end of Firle. It's a one street village.

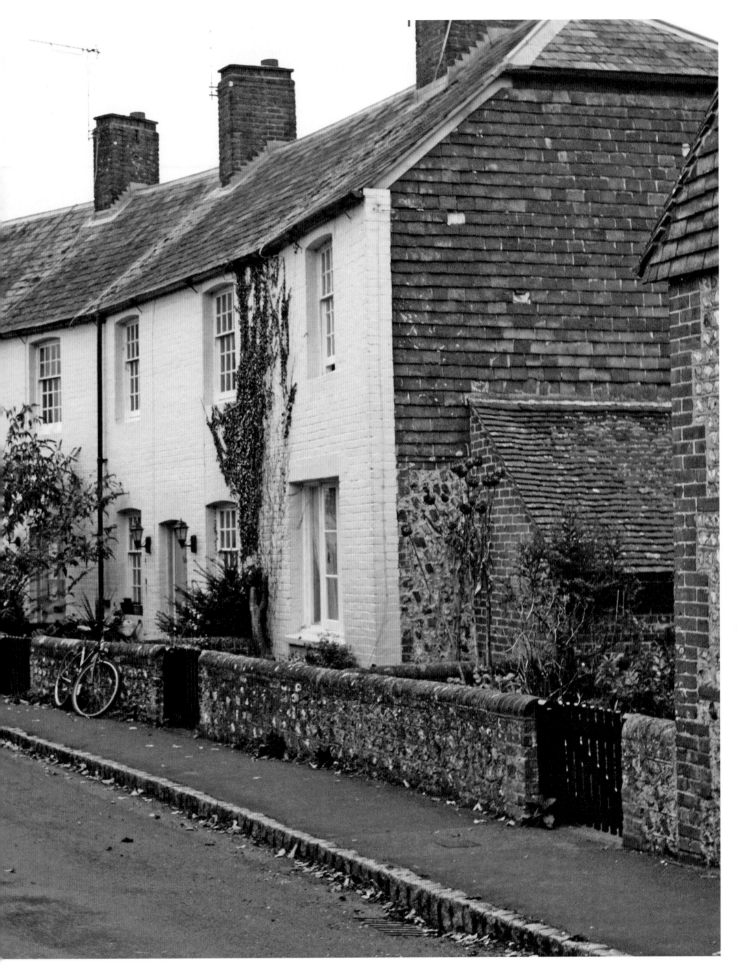

Landlady Hayley Bayes with her locals.

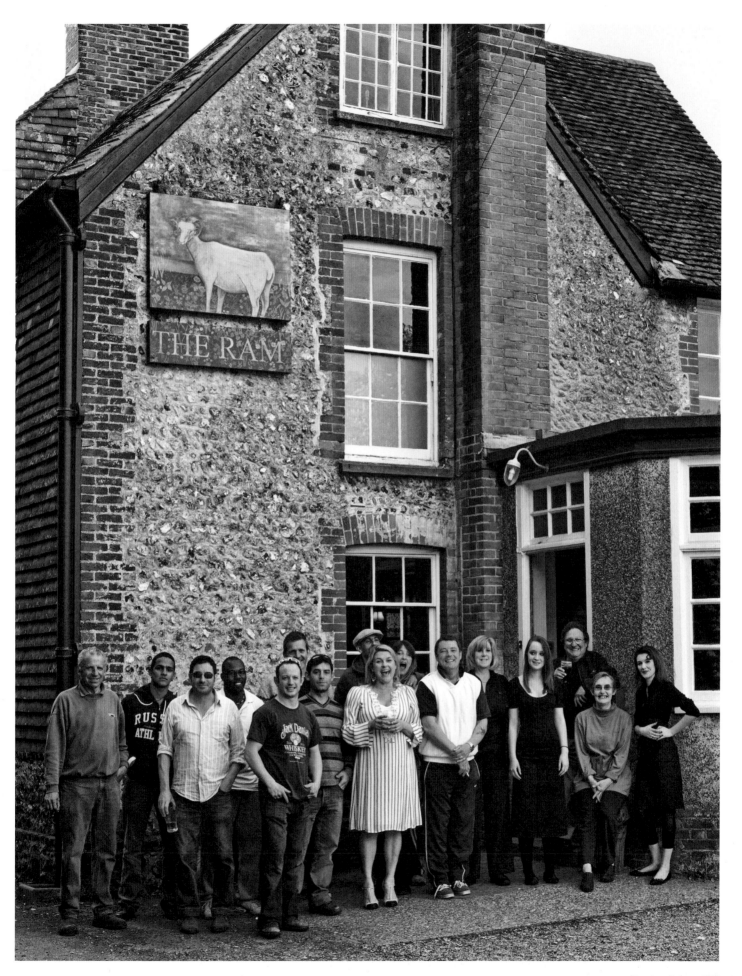

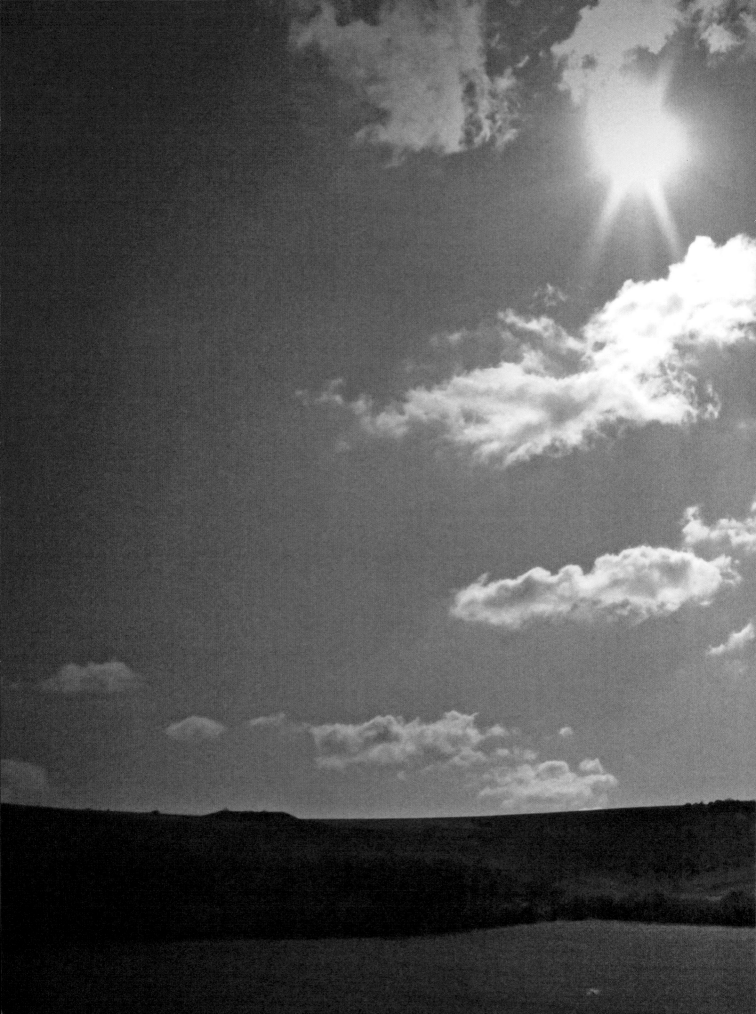

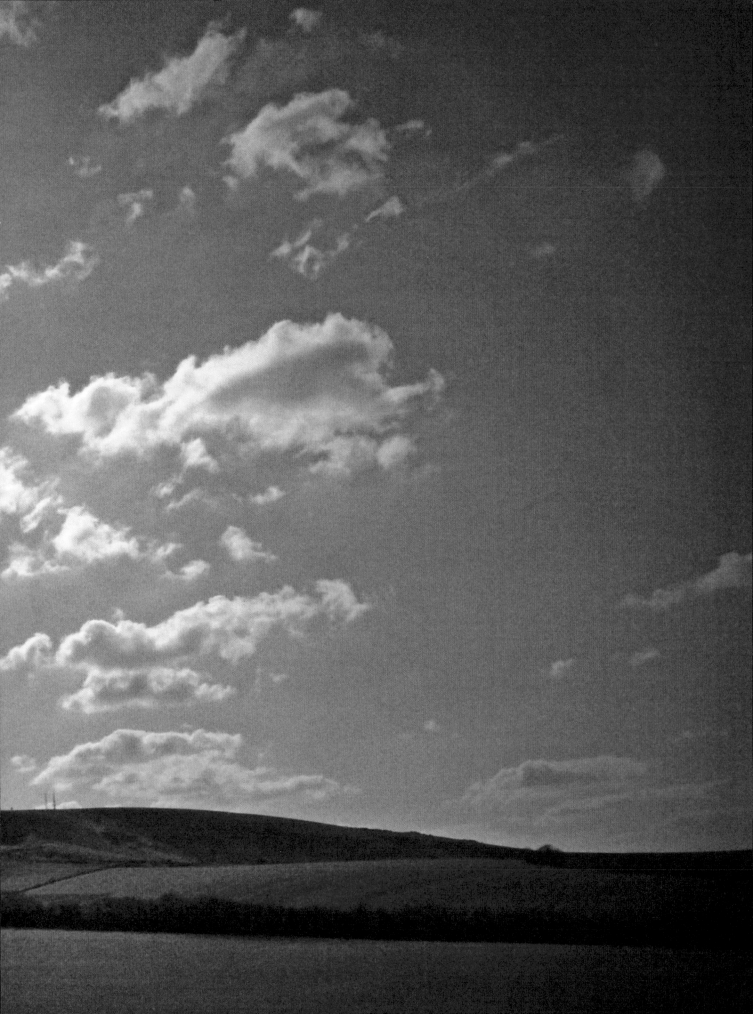

acknowledgments

Many thanks to all of the villagers (in sort of alphabetical order)

Alex Ashen, George Ashen, Ray Ashen, Simon Ashen, Riyadh Abu Omar, Isabel Abey, Annwn B.C. members Chef, Steve, Sog, Tug, Russell, Damage, George, Marlon, Rick, Glen, Marcus, Jamie, Haddock, Nick. Ann Barnes, Hugh Barnes, Haley Bayes, Andrew Barr, Debbie Barr, Alice Barr, Tom Brunt, Julie Burrows, Mia Brimilcombe-Cowie, Ave Brimilcombe-Cowie, Cici Bowker, Rosie Brown, Gwen Butcher, Matte Breech and Cuddles, Norman Beanie, James Brown, Colin Browning, John Cross, Terry Clark, Steve Canning and Dee, Josephine Constable, David Cooper, Liam Carter, Helen d'Ascoli, Eden d'Ascoli, Mark d'Ascoli, Mark Doyle, Jim Downing, Marylin Dawson, Greg Ellis, Orde Etherington, Annie Etherington, Iona Foster-Gandy, Luke Freeman, Antony Freeman, Caroline Fuller, Ken Filtness, Brian French, Trevor Foord, Tom Gribble, Eddie Gribble, Richard Gravett, Jack Gravett, James Gravett, Robert Gravett, Molly Gravett, Miguel Rondon Gonzales, Ellie Gaston, Liam Gleenson, Bluebell Gilvan-Cartwright, Harvey Harrison-Doyle, Tom Harrison, Andy Hughes and Sky, Eric Hole, Will Hole, Mike Hole, Will Hecks, John Hecks, Linda Hughes, David James, Efan James-van Dyke, Laura James-van Dyke, Ellen Kydd, Tanwen Kydd, Terrie Knight and Eddie, Anabelle Jellings, Jeff Johnson and Poppy, Glyn Jones, Karen Lee, Nigel Lee, Charlie Lambert, Immie Longley, Hannah Lewis, Nathan Lewis, Flynn Mooncie, Miriam Mooncie, Honey Mooncie, Stuart Martin, Lauren McGoldrick, Lauren Myers, Rod Marsh, Helen Marsh, David Moore, Adam Moore and Jema, Peter Owen Jones, Izzy O'Nunain, Katie O'Nunain, Nick Pierce, Robert Pratley, James Pratley, Louis Partington, Clare Partington, Ella Partington, Lorraine Phillpot, John Payne and Tosh, Sheila Payne, Madison Piper, Mark Peters, Anna Richardson, Peter Setterfield, Andre Samuel, Anna Speight, John Stocken, Martin Saunders, Mandy Saunders, Joel Saunders, Dave Tritton, Ernie Vine, Graham Vincent, Tina Vincent, Gavin Ward, Bella Wingate Saul, Matty Wolstenholme, Derek Wood, Miles Walton, Laurence Williams, Penny Woolgar, Peter Woolgar

business credits

E. J. McCabe www.ejmccabe.com
Karen Harrison karen.harrison10@virgin.net
Sophie Coryndon www.sophiecoryndon.co.uk
Matthew Burrows www.matthewburrows.org
Tom Palmer www.opiium.com
Chris Gilvan-Cartwright www.gilvan.co.uk
Carola van Dyke www.carolavandyke.co.uk
Chelsea Renton www.chelsearenton.com
Caroline Fuller www.countrysidecatering.co.uk
Middle Farm www.middlefarm.com
Lorraine Phillpot www.firleforge.co.uk
The Ram Inn www.raminn.co.uk

We would like to also thank the following people for all their support and enthusiasm: Andrew Barr, Ian Pepe and the Village Hall Committee, Ami Reece at the Firle Stores, the Gage family, Haley Bayes and her staff at The Ram Inn, Richard Gravett and the Bonfire Society members, Emma Ricca and Douglas Kidd at Firle School, John Coldman and Michael Rees of the Firle Shoot, Caroline Fuller and the Hunt, Carola van Dyke and Matt Richmond for their help with the production of this book.

The pictures in the book will be on sale at The Ram Inn, Firle, as part of an ongoing exhibition from September 2011. All royalties made from the sale of this book will be donated to the Firle Memorial Hall to aid its renovation. Prints are also available for sale directly from the photographer. All enquiries please contact eamoo@me.com

Photographers Assistant Belinda Foord